SECRET WREXHAM

John Idris Jones

AMBERLEY

This book is dedicated to the memory of Edward Hubbard, who, despite not being able to drive a car, produced, in his 'CLWYD: Denbighshire and Flintshire' (Penguin Books, 1986), the most accurate and complete guide to the historical buildings of what is now Wrexham County Borough.

Thank You to Christie Evans of Fineline, Ruthin, for work on the images.

First published 2018

Amberley Publishing
The Hill, Stroud, Gloucestershire, GL5 4EP
www.amberley-books.com

Copyright © John Idris Jones, 2018

The right of John Idris Jones to be identified as the Author of this work has been asserted in accordance with the Copyrights, Designs and Patents Act 1988.

ISBN 978 1 4456 7700 2 (print)
ISBN 978 1 4456 7701 9 (ebook)

British Library Cataloguing in Publication Data.
A catalogue record for this book is available from the British Library.

Origination by Amberley Publishing.
Printed in Great Britain.

Contents

Foreword

It was with great pleasure that I agreed to write the foreword to *Secret Wrexham*, as a proud man of the town.

Over the centuries, Wrexham has reinvented itself from an area reliant upon heavy and traditional industries into a major manufacturing, technology, retail and services hub in North Wales. Wrexham hosts a mixture of urban delights, including historical markets, an award-winning retail town centre and a bustling nightlife.

The town has a long history of providing higher education in the region, with roots going back to 1887. Wrexham Glyndŵr University is a strong presence in the town and Elihu Yale, the founder of Yale University in the USA, is buried in St Giles' Church.

Our rural treasures are captivating and we boast three of the Seven Wonders of Wales, not to mention a World Heritage Site, castles, churches and two National Trust properties. In addition, the County Borough Museum hides some of Wales' hidden gems, which include the Welsh Football Collection.

We are delighted to be the home of the Wrexham AFC, the oldest football club in Wales, with the Racecourse Ground being the oldest international stadium in the world.

Wrexham people are proud to be Welsh and are keen to show it. Over recent years we have seen a huge increase in Welsh medium education, resulting in a major increase in Welsh speakers among our youth. This positive change has strengthened the Welsh language in the area.

I hope that you enjoy learning more about Wrexham. I am certainly looking forward to learning more about the place I call home.

Councillor John Pritchard
Mayor of Wrexham

Introduction

I was born in the village of Llanrhaeadr-ym-Mochnant, in the Tanat Valley of north-east Mid Wales. It was a small, quiet place, immersed in the old ways of Nonconformist Wales. Around us were the Berwyn Hills – tall, craggy and arid – but one road led away eastwards, linking us with Oswestry, which was in England. My parents went shopping there at weekends, or they went to Wrexham, Chester or Shrewsbury. Each of these towns had a special atmosphere: three of them were similar, but one, Wrexham, was different. We knew it was in Wales because we heard the language spoken in the streets, and when my mother addressed a lady over the counter in a clothing shop, she spoke in Welsh.

I got to know Wrexham quite well. We would have lunch in the Wynnstay, looking down High Street, served by a waitress in full uniform. Sometimes we had tea at Stevens' Café, facing a plated stack of cakes, the teapot in a cosy. My father had started his banking career there, in a tall building faced with columns. In preparation for the First World War and later, the town (which failed a number of times to become a city) recruited a large number of young men from across the region. The Royal Welch Fusiliers were to be seen in the streets, their caps carrying a plume of white feathers.

The football team were always an attraction. There have been many exciting moments involving promotion. At the time of writing, the team is not within the Football League, but hope prevails.

This book is an attempt to capture something of Wrexham's special atmosphere. Its past is industrial, heavily dependent on coal mining and iron and steel manufacturing. However, the pits have closed, and what has happened afterwards shows manufacturing in quantity, with substantial employment in at least four industrial estates, and retailing has flourished.

The town has in the region of 61,000 inhabitants, but the county borough as a whole has more than double this number. It stretches to the English border towards Chester and in the other direction towards Shrewsbury. This larger area has rich pastureland and distinctive villages with stylish architecture. The essential secret of this book is the extreme contrast between the town of Wrexham and its very close and extensive rural hinterland.

This book is an attempt to reveal the quirky, the local stories, the symptomatic, the figures of history and leaders of industry, the industrial relics and peculiar architecture and landscape. I hope that this kaleidoscope of words and images becomes – for the reader – greater than the sum of its parts.

1. John 'Iron Mad' Wilkinson (1728–1808)

DID YOU KNOW ?

John Wilkinson was buried in an iron coffin.

Industrial Wrexham began in 1762 with the opening of an ironworks at Bersham, a village (later a suburb) on the western fringes of the town. There were substantial deposits of coal and iron ore underground across Wrexham. These were the source of a process that, at its busiest point, employed some 18,000 men.

The North Wales Coalfield stretches from Point of Ayr on the north coast, on the mouth of the River Dee, down to the border of Wales and England near Shrewsbury. Coal is necessary for coking and smelting. The ironworks at Bersham started in the mid-seventeenth century, iron ore, charcoal, limestone, and water power were initially needed. Later coal was needed and this came from Ponciau, Rhos and Llwyn Einion.

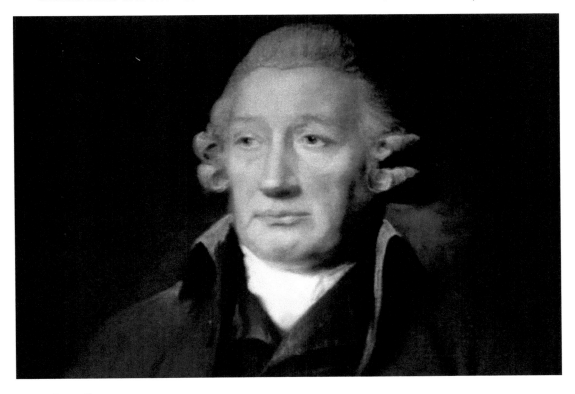

John Wilkinson.

The River Clywedog supplied water, and limestone came from quarries in Minera. The Bersham ironworks was taken over by John Wilkinson in 1763.

The Brymbo estate, which John Wilkinson bought in 1792, had deposits of coal and iron ore. John Wilkinson was a specialist in the making and use of cast iron. He invented a machine that could create a bore in cast-iron cylinders, making steam engines more efficient. He also made blast furnaces more successful by inventing a blowing machine that increased the temperature.

His Brymbo works produced guns and cannons. By 1796 he was producing a significant part of Britain's cast iron, and he was appointed Sheriff of Denbighshire in 1799. His children, a boy and two girls, were born in Brymbo Hall. He was buried in what is now Cumbria in an iron coffin (now lost).

2. Coal Mining in Wrexham

DID YOU KNOW ?

The main coal mines in Wrexham were around 2,000 feet deep.

Bersham colliery.

There were four large coal mines in Wrexham: Bersham, Hafod, Gresford and Llay Main. There were also small pits, and in 1854 twenty-six mines were functioning in Ruabon, Rhos, Acrefair, Brymbo and Broughton.

In 1948 the pits were nationalised, while closure came in the 1960s, '70s and '80s: Bersham, with 700 men employed, was closed in 1986; Hafod (next to Bersham) closed in 1968; and Gresford closed in 1973. The impact on Rhos, where the Bersham and Hafod colliers lived, was catastrophic.

It is reckoned that at its highest point there were thirty-eight pits in Wrexham, employing a maximum of 18,000 people.

3. Wrexham's Geography

DID YOU KNOW ?

Wrexham County Borough has a population of over 135,000.

River Clywedog at Bersham.

We sometimes do not realise that the name 'Wrexham' applies to two areas: the town itself, the central conurbation, which in the census of 2011 had a population of 61,603; and the larger county borough area (which includes the above), with a total of 136,600 inhabitants in 2015. This corresponds, generally, to a split heritage of industrial and rural – west and east. The county borough is the largest in North Wales and Wrexham town is the fourth largest urban area in Wales.

In this book, we are concerned with the larger county borough area. This is located between the mountains of North Wales (especially the Berwyn range to the south-west) and the River Dee as it flows to the sea at Chester. This area runs down part of the Wales–England border, from Rossett in the north (only some 4 miles from Chester) to Hanmer, Bronington and Bettisfield in the south (13 miles north of Shrewsbury) and to the south-west, including the Ceiriog Valley, an outstanding area of rural beauty.

Its secret is essentially its mixed heritage, from trading, manufacturing and heavy industry in Wrexham town to the farming hinterland to the east and south. This book tries to cover that variety.

The River Clywedog rises in the hills west of Minera and was key to the industrial development of Wrexham. During the eighteenth and nineteenth centuries there were seventeen watermills along the river, servicing the cloth, corn and malt (for brewing) and paper mills.

4. The Name

The most reliable explanation for the name Wrexham is that it is derived from 'Wristlelessham'. This was a name given to the area in 1161 by Hugh de Avranches, Earl of Chester, who founded a motte-and-bailey castle in the Erddig area.

The Welsh lordship of Maelor stems from the eleventh century, when the Welsh took over control from the Vikings and Anglo-Saxons. The Welsh controlled the area known as Powys Fadog in the early thirteenth century, including Chester and parts of Cheshire.

The Cistertian abbey of Valle Crucis, near Llangollen, was founded by the Lord of Dinas Bran and in 1202 part of his land was granted to 'Wrechcessham', which is another early form of Wrexham.

The present name is in English form because there is no 'x' in the Welsh alphabet.

Road sign near Chester.

5. The Myddeltons of Chirk Castle

The castle was built in 1295 as part of Edward I's chain of fortresses across North Wales, and guarded the entrance to the Ceiriog Valley. It was bought by Sir Thomas Myddelton in 1593 and inherited by his son of the same name.

Despite Wrexham being on the side of the Royalists in the Civil War, Sir Thomas Myddelton was a supporter of the Parliamentarians. The family, not to be confused by a recently famous family of a similar name, have been embroiled in disputes in the past: sometimes over ownership/inheritance of land and sometimes over political allegiance.

The castle passed down the family to Charlotte Myddelton in 1796, who married Robert Biddulph; consequently the family were called Myddelton-Biddulph. The family occupied the castle until 2004. Lieutenant-Colonel Ririd Myddelton was an equerry to Elizabeth II from 1952 until his death in 1988.

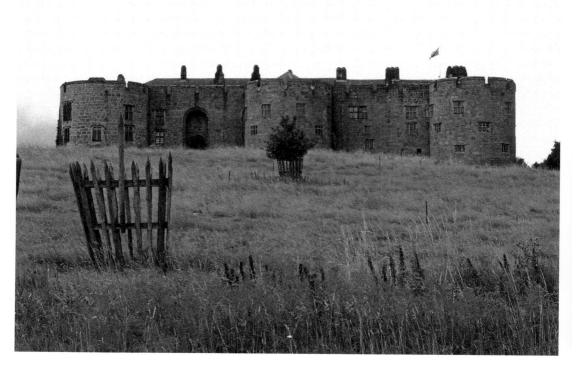

Chirk Castle.

6. Penley and the Poles

Penley is a village on the south-west border of Wrexham County Borough. Two large American Army hospitals were built here, with a combined bed total of 2,000, in preparation for casualties of D-Day landings in the Second World War. Another was created near Whitchurch.

After the war, a detachment of the Polish Resettlement Corps arrived from Italy and the empty hospital buildings were occupied by injured Polish soldiers and civilians. These were a portion of those who were effected as a result of Russian and German incursion into Poland. Two hospitals functioned in Penley treating Polish immigrants. Courtesy of the US Army leaving good equipment behind, Hospital No. 3 in Penley functioned well – it had its own X-ray and operating facilities. However, there are 180 Polish graves in St Mary Magdalene Church. In the 1950s it even had a small cinema.

Remains of the Polish camp at Penley.

In 1961 the hospital took on a new role: caring for the old, disabled and chronically sick. The Polish hospital had 720 beds in 1947, but by 2002 only six patients remained in one of the thirty wards on the site.

Some of the original buildings still remain, many of them now used by small businesses.

7. The Ceiriog Valley

If anywhere deserves the appellation 'secret', this place does. It is different from the rest of Wrexham County Borough, being a long, winding valley in an entirely remote rural setting. It is a Welsh-language enclave.

The river is the Ceiriog – 18 miles long – which begins deep in the Berwyn mountains at an altitude of 1,800 feet. It flows quickly under old trees, twisting and curving its way towards Chirk, where it flows below the castle. It is loved by trout fishers, and grayling are also present. At Chirk, the Llangollen Canal flows over the river in an aqueduct, and the Ceiriog joins the Dee to the east of the town. The river, in its lower stretches, marks

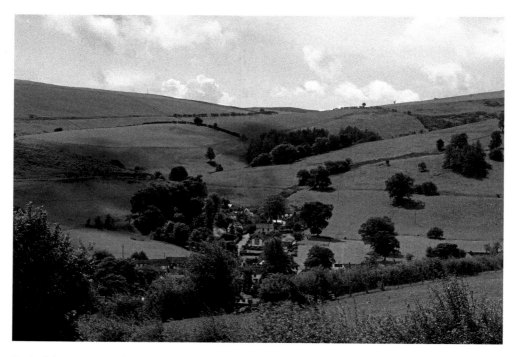

End of the Ceiriog Valley, with Llanarmon district below.

the boundary between Wales and Shropshire. David Lloyd George said that this valley was 'a little bit of heaven on earth'.

Three communities punctuate the Ceiriog Valley: Pontfadog, Glyn Ceiriog and Llanarmon Dyffryn Ceiriog. Pontfadog is an old quarrying village, while the valley once boasted a tramway with a stop here, which is preserved by the Glyn Valley Tramway Group. An oak tree here was said to be the oldest living tree in the UK; sadly it fell in 2013. It had made its home here for 1,200 years, and its girth was measured at 53 feet.

Glyn Ceiriog is some 6 miles west of Chirk. The tramway was built to take locally quarried slate to the Shropshire Union Canal and later to the Great Western Railway, linking Chester to Shrewsbury. The Welsh novelist Islwyn Ffowc Elis spent most of his childhood at a farm near the village, although he was born in Wrexham.

Llanarmon Dyffryn Ceiriog is at the end of the valley, accessible along the B5000. It is 10 miles north-west of Oswestry. It has its origins in the 'drovers' – men who drove animals long distances to market. The two local inns, the West Arms and the Hand, were places of accommodation for them. Their names attest to their connections with two prominent families: the Myddletons of Chirk and the Wests of Ruthin Castle. The original local Church of St Garmon was founded in the fifth century, indicating the longevity of settlement here.

This valley is heavily agricultural, with farms being passed down the generations for many centuries. Welsh is spoken widely here: in the 2001 census, over 55 per cent of the Ceiriog Valley were Welsh-speaking. In the hills above in 1969, a BBC researcher found elderly residents who could not speak English.

8. John Ceiriog Hughes (1832–87)

This is a story of a young man growing up in the country, going to find work in the big city and dying young at fifty-four. There are echoes of Wordsworth's 'Michael', and like Wordsworth, John Ceiriog worked towards simplicity and the vernacular in his writing.

He was born in this valley overlooking the village of Llanarmon Dyffryn Ceiriog. His mother, Phoebe, was a midwife and an expert at herbal medicine. He was one of eight children. He left the village at eighteen and moved to Manchester, where he kept a shop. He returned to Wales in 1865, taking up the post of stationmaster at Llanidloes. He died in poverty.

All this is sad and a great contrast with his poetry, which was positive and direct, showing a great love of the countryside, and like William B. Yeats, he wrote with nostalgia about his past. He was a lyric poet of distinction. He wrote lyrics for songs, including the haunting 'Dafydd y Garreg Wen', the unforgettable 'Ar Hyd y Nos', the Welsh words of 'The Bells of Aberdyfi' (Clychau Aberdyfi) and the Welsh rousing lyric to 'Men of Harlech'.

His four-stanza poem 'Nant y Mynydd' has the following as the first stanza:

> Nant y Mynydd, groyw loyw,
> Yn ymdroelli tua'r pant,
> Rhwng y brwyn yn sisial ganu:
> O nab awn I fel y nant!

John Ceiriog Hughes.

Here is a translation:

The mountain stream, clear and pure,
Turning down to the valley,
Between the bracken finely singing:
Oh how I wish to be that stream!

9. Lloyd George and the Suffragettes

The National Eisteddfod took place in Wrexham in 1912 from 2–7 September. That year was the height of activity during the suffragette movement. Police Constable Dan Ellis was twenty-one years old at the time, and he and his colleagues supervised the event. President on Chairing Day (celebrating the winning poet) was Chancellor of the Exchequer David Lloyd George. He had arrived by train and was met by police and detectives, then was taken to the Eisteddfod site by taxi.

There were 'scuffles in the audience' on that day. PC Ellis and his colleagues stepped forward to quell the disturbance. Lloyd George's speech was interrupted by vocal women; the ladies became more insistent and drew their hatpins from out of their hats. PC Ellis commented, 'several of us were injured in the fleshy part of our anatomy when some of the ladies used their hatpins on us'. PC Ellis retired in 1939 but returned as a reservist during the Second World War.

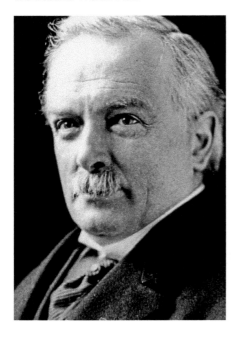

David Lloyd George.

10. The Brewery and its Chimney

DID YOU KNOW ?

Wrexham Lager Brewery is the oldest in the country.

Under the name of Border Breweries, Wrexham made a significant contribution to the brewing industry in Wales, largely from 1834 to 1874, but the company flourished for 150 years until 1984. The company was the first in the UK to brew and distribute lager. It is believed to have been started by men who came over from Bavaria.

There was suitable spring water and Wrexham Lager Brewery dominated the production of ale in the mid-nineteenth century. The Soames family built the red-brick chimney that

The brewery chimney.

we see today. The product was sold through North and Mid Wales, Shropshire and the Potteries. For years, Wrexham Football Club was owned by the brewery and had a 'Border Stand' for many years.

In 1984 the business, with its 170 tied houses, was acquired by Marstons, and the Border site was closed. The chimney was purchased by local Member of Parliament John Marek, preserving an important Wrexham landmark. In 2001 local MP Martyn Jones bought the rights of Wrexham Lager off Carlsberg for £1.

The original Border site in Tuttle Street has been turned into flats. The nearby Nag's Head, where the business started, is still active. A new brewery using the logo 'WXM LAGER' has been set up and production started in 2011. Now, Britain's oldest lager brewery is back in production, drawing its water from the River Gwenfro.

11. Fron Choir and Pavarotti

The Froncysyllte Male Voice Choir was formed in 1947. It has close links with the Llangollen International Musical Eisteddfod. In 1955 the choir and village hosted Choral Rossini, a male choir from Modena, Italy. It included the nineteen-year-old Luciano Pavarotti, who at the time was training to be a teacher. His father, Fernando, was in the choir. They won first

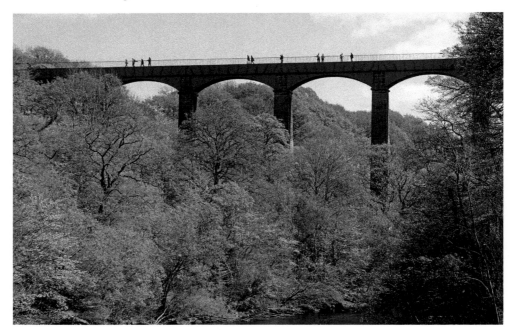

Fron Aqueduct.

prize, and Gwyn L. Williams said, 'Pavarotti was always referring back to the experience as the most important in his life and which inspired him to turn professional.' The tenor returned to Llangollen Eisteddfod in 1995 to great acclaim.

The Fron choir released an album called *Voices of the Valley* in 2006, which made No. 9 in the UK album chart. It became the largest selling classical music album ever, making gold status in three days. By 2009 it had sold over half a million copies

12. Parry-Thomas, Racing Driver

DID YOU KNOW ?

A Wrexham man set a world land speed record.

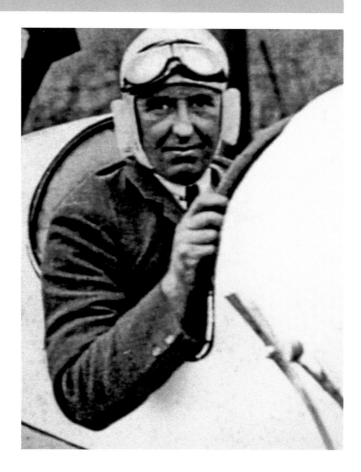

Parry-Thomas.

John Godfrey Parry-Thomas was born at No. 6 Spring Road, Wrexham, in 1884. He worked as an aero-engine designer in the First World War and was afterwards chief engineer at Leyland Motors. In 1923 he became a professional driver at Brooklands, Surrey. In 1924 he purchased a Higham sports car, believing it capable of setting speed records. It had a V12 American Liberty engine, which Thomas modified by fitting new pistons of his own design. He altered the body design and named the car *Babs* after a favourite niece.

On April 27 1926 he broke the world land speed record in *Babs* on Pendine Sands. A two-way drive set a speed of just over 169 mph. He returned the following day and this time set a speed record of 171 mph; he had set a world record for four-wheeled cars.

Parry-Thomas returned to Pendine on 1 March 1927. On his sixth pass, when onlookers believed he was travelling at 180 mph, the car crashed and Parry-Thomas was killed. He was buried close to Brooklands.

In 1967, the car was removed by enthusiasts and restored in a garage in Capel Curig. *Babs* can be seen at the Museum of Speed at Pendine Sands.

13. Seb Moris, Marford Driver

In 2017 the British Racing Drivers' Club (BRDC) named Seb Morris 'Super Star' in acknowledgement of his successful career as a racing driver. In 2011 he was named by the WRDA as 'Welsh Young Driver of the Year'. He has raced with Formula Renault and in

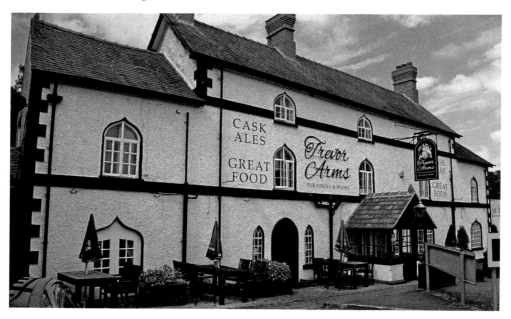

Trevor Arms, Marford.

2013 was in the BRDC Formula Four Championship. He took pole position in the Brands Hatch Formula 3 race in 2016 and has taken other pole positions in races at Silverstone and Oulton Park. He is currently with Team Parker Racing.

14. The Telford Inn

DID YOU KNOW ?

When the famous aqueduct was built, the village of Trevor did not exist.

This inn's secret is that it has a direct connection with the famous designer and engineer Thomas Telford. He had it built in 1793 so that when he came to visit the site of one of his buildings or structures, he had somewhere to live – a bedroom was kept for his convenience. It was originally called 'Scotch Hall' because it was occupied by Scotsmen who came down, at Telford's request, to work on the aqueduct.

Telford Inn, Trevor.

This popular inn is in Station Road, Trevor. It sits next to the Llangollen Canal, and on the Llangollen side of the aqueduct is the village of Froncysyllte (on the A5). This aqueduct and canal is a World Heritage Site, with Grade I heritage status. The inn has hundreds of visitors a year who come armed with detailed knowledge of the designer genius, who was born in Scotland to a poor agricultural couple. Staying or dining here gives them a direct link to the famous man.

15. The Pontcysyllte Aqueduct

DID YOU KNOW ?

This structure is the oldest and longest navigable aqueduct in the UK, and the tallest in the world.

This amazing structure, designed by Thomas Telford, has eighteen arches, with the piers in stone and the water-holding troughs in cast iron. It is 336 yards long, with a width of 4 yards and a height of 126 feet. It took ten years to build and was completed in 1805. Four of the piers are in the River Dee.

The main reason why it was built never came to fruition. It was to carry the Ellesmere Canal, which would comprise a goods-carrying conduit between the River Severn at Shrewsbury and

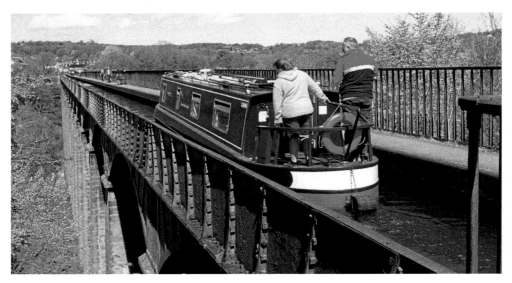

Pontcysyllte Aqueduct.

the River Mersey at Liverpool. Only a part of the canal route was completed, and the revenues expected never materialised. It was to be linked to the coal, iron ore and lead deposits of Wrexham. These could have created larger revenues if their carriage had been via Liverpool.

The aqueduct has piers that are hollow above the height of 70 feet. The supply and erection of the ironwork was created by William Hazeldine of Plas Kynaston Ironworks. The substance used to join the metal plates was Welsh flannel, impregnated with white lead. In 1804 a narrow waterway was created from the northern end of Pontcysyllte along the Dee past Llangollen, and a large weir was constructed close to the Dee where river water supplied the canal.

William Jessop, an engineer, had a major part in conceiving and building the original edifice. Its contractor was John Simpson; its supervisor of works was Matthew Davidson; William Reynolds, ironmaster, contributed his knowledge; and Thomas Telford was chief.

The opening of Pontcysyllte on 26 November 1805 was accompanied by gun firing and singing. It was said that 8,000 people attended.

16. Thomas Penson (1790–1859)

Thomas Penson was the country surveyor of Denbighshire and Montgomeryshire. He designed bridges over the River Severn and was active in creating black-and-white

Façade of the Butchers Market designed by Thomas Penson.

buildings in Chester. Thomas Harrison, of that city, was his early mentor. He was appointed Fellow of the Royal Institute of British Architects in 1848. His wife was a daughter of Frances Kirk, the Wrexham ironmaster. They originally lived in Overton-on-Dee. In 1839 his wife inherited Gwersyllt Hall from her father. Penson remodelled the building, adding some of his favourite Jacobean designs. Penson was appointed Deputy Lord Lieutenant for Denbighshire in 1852, and died at Gwersyllt in 1859.

The design for Rhosllanerchrugog Church was Penson's, and he also designed Sontley Bridge, near Wrexham; Grecian or Romanesque would be terms descriptive of Penson's designs, which displayed an original use of terracotta. The façade of the Butchers Market in High Street, Wrexham, is by Penson.

17. Wynnstay Hall

This large house and land was occupied during the seventeenth century by Sir John Wynn, 5th Baronet, and his wife Jane. The gardens were laid out by Capability Brown. In 1858 the house was destroyed by fire and much of its contents destroyed, including valuable paintings and furniture. It was rebuilt on the same site and is now a Grade II-listed building.

In the twentieth century the Williams-Wynn family vacated in favour of Plas Belan, on the Wynnstay estate, and the house was bought by Lindisfarn College, a private school. After that it became bankrupt, and the building was divided in to flats and private residences.

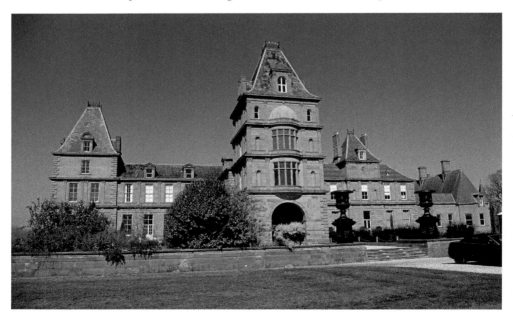

Wynnstay Hall.

The present Sir David Watkin Williams-Wynn is the 11th Baron of Bodelwyddan. His ancestors were prominent parliamentary and landowning family, with Wynnstay as their family seat. In the seventeenth century the Williams and the Wynn family combined. Jane Thelwall, the heiress of Sir John Wynn, inherited the Wynnstay estate in 1719 and her husband Watkins Williams adopted the Wynn family name.

The Williams-Wynn family were one of Wales's wealthiest for over 200 years. Sir Watkin Williams-Wynn (1749–98), 4th Baronet, was a patron of artworks and music. He built a theatre at Wynnstay at which the great David Garrick once appeared. On his death, he owed £160,000. The next Sir Watkin (1772–1840) founded the Wrexham Agricultural Society in 1796. He dismantled the theatre and converted it to the use of an annually held agricultural show. He also raised a fighting force for the French Revolutionary War ('Sir Watkin's Lambs').

18. Horses for Courses: Bangor-on-Dee

Situated in a very rural area, Bangor-on-Dee racecourse is a small distinctive racecourse without a grandstand. It is left-handed and for thoroughbred horses under National Hunt rules. Racing started here in 1859. Local hunts use this course for Point-to-Point races, the course for which is inside the main track and runs right-handed.

Racing here at present is owned and run by the Chester Race Co. Ltd and they share the same clerk of the course.

Bangor-on-Dee racecourse.

19. The Gresford Mining Disaster

It was early morning of 22 September 1934 when 266 men and boys lost their lives, many children lost their fathers and more than 200 women lost their husbands and loved ones.

The pit at Gresford was sunk in 1908. Two shafts were built 50 yards apart: the Martin and the Dennis. The two shafts reached over 2,000 feet deep. In 1934 2,200 men worked here – 1,850 working underground and 350 on the surface. Three coal seams were worked. The explosion occurred in the main seam of Dennis. Poor air quality was supplied and a return ventilation shaft was too small. There were numerous breaches of safety regulations, such as the incorrect firing of explosive charges. At the time of the explosion 500 men were working here.

In the House of Commons in February 1937, following the release of the Walker Report, politician David Grenfell spoke: 'There is no language that can describe the inferno of the 14s. There were men working almost stark naked, clogs with holes bored through the bottom to let the sweat run out, 100 shots a day fired in a face less than 200 yards wide, the air thick with fumes and dust from blasting.'

Only eleven bodies were recovered from the mine – eight miners and three rescuers. The Dennis shaft was never reopened: the bodies of the other miners were left inside, in the sealed districts.

By the end of September 1934, 1,100 Gresford miners had signed on the unemployment register. Relief funds raised £556,000. Stafford Cripps called for the nationalising of the coal industry, and the National Coal Board took over in 1947.

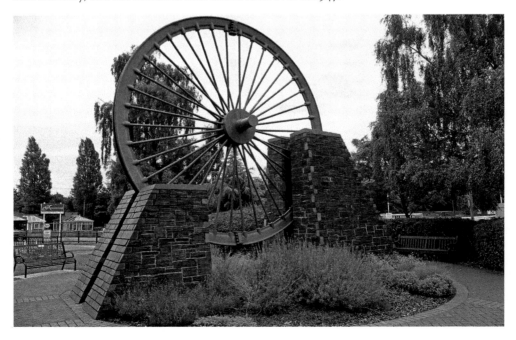

Gresford Colliery memorial.

20. Llay Main – the Deepest Pit in Europe

DID YOU KNOW ?

During the Second World War, the Halle Orchestra, under the baton of Sir John Barbirolli, performed in the Llay Welfare Institute.

Llay is a community some 5 miles outside Wrexham, in the Chester direction. It is surrounded by rich farmland and has two large industrial estates. The extraordinary thing about it now is that not a trace of the once-huge pit remains. It is believed to have been on the site of the present-day Asda.

This colliery was started in 1914, when two shafts were sunk; the work was completed in 1921. The downcast shaft was 2,715 feet deep. After nationalisation in 1947, the shafts were deepened to 3,000 feet. In 1923 there were 2,013 men employed, mining house and steam coal, which rose to 2,501 in 1945.

Llay Main had a reputation for being a 'happy pit'. Its owner, Sir Arthur Markham, had a caring attitude towards his workers and the mine had very modern equipment, including electric lighting along its main corridors. The coal was machine cut, with conveyor belts for shifting. Tubs of coal were moved over rails by ropes and no ponies were used.

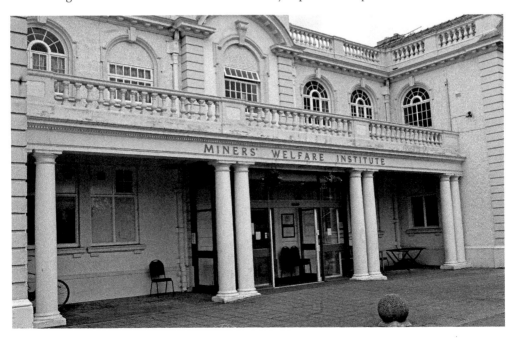

Miners' Institute, Llay.

Like Port Sunlight, Llay village was built to accommodate workers. Houses were well supplied, each house containd an indoor bath and toilet and a garden for growing vegetables. Electric power was available at 9*d* a week. In the colliery, pit baths were installed in 1931.

The substantial Miners Welfare building, which was built in 1931, became a focus for social and cultural activities. During the Second World War there was a performance by the Halle Orchestra conducted by Sir John Barbirolli.

Curiously, the location of the pit has disappeared. Very few of the local people know where it was, but a clue lies in the local 'Miners Road'.

Drive in the Llay direction and you can't miss The Crown Inn. With its deep carpet, polished furniture and odour of good cooking, it's the star of the show.

21. George Jeffreys, 'The Hanging Judge' (1645–89)

Welsh judge George Jeffreys was notorious for his lack of compassion in the courts of justice. He was born at Acton Hall, Wrexham. His father was High Sheriff of Denbighshire in 1655. He attended Shrewsbury School, St Paul's and Westminster School, London, and studied at Trinity College, Cambridge, then the Inner Temple, London.

He started his legal career in 1668, becoming Common Serjeant of London. Two men had stolen lead from the roof of Stepney Church. It was commented that they 'had a zeal

Acton Hall.

for religion … so great as to carry you to the top of the church, and noting that they had narrowly avoided committing a capital offence'. Jeffreys became Recorder of London in 1678 and Lord Chancellor in 1685–88.

Presided by Jeffreys, the Bloody Assizes of 1685 saw the accusation of treason handed out to rebels connected with Monmouth's Rebellion. Some records cite the number of executed as 180. The execution of Alice Lisle at Winchester took place even though she took no part in the rebellion.

22. Elihu Yale (1649–1721)

DID YOU KNOW ?

The man who gave his name to Yale Univeristy, USA, lived in Wrexham.

Yale's claim to fame is that he was a benefactor for an educational establishment in the colony of Connecticut, which was renamed Yale College after him, the third oldest university in the USA. He was born in Boston, Massachusetts, to David Yale and Ursula. The name Yale is derived from the rural area between Ruthin and Wrexham, close to

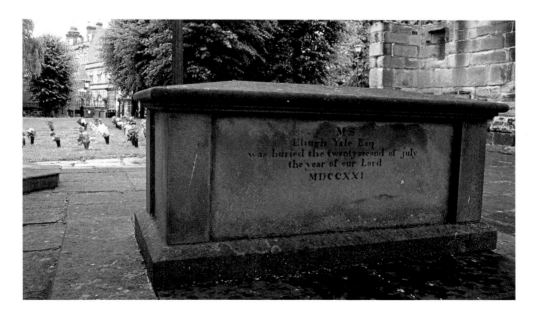

Elihu Yale's grave, St Giles' Church.

Llandegla. The boy was taken to England when he was three years old and never returned to the US. He was educated in London.

In 1671 he began working for the East India Company and he became governor of Fort Saint George in Madras. He became alienated from the organisation and returned to England in 1699 with a substantial fortune.

Yale made a donation of thirty-two books to the US institution then known as the Collegiate School of Saybrook. In 1718 Cotton Mathyer wrote to them, now at New Haven, saying that the college should rename itself after their benefactor. This was done by charter in 1745. In the meantime, Elihu Yale had presented more books and a valuable portrait to the institution.

Yale's epitaph on his grave in Wrexham churchyard was composed by himself. It reads,

> Born in America, in Europe bred,
> In Africa travell'd, and in Asia wed,
> Where long he lov'd and thriv'd;
> At London dead.

The house where he lived in the Wrexham area was called Plas Grono and was built originally by Elihu Yale's great-grandfather. The present Plas Grono Farm, with some 4 acres of land, was part of the Erddig estate. After 1699, Elihu Yale lived here and in his London house until his death in 1721. The house later burned down; the present building is on the same site.

23. The Church of Saint John the Evangelist, Rhosllanerchrugog

This church was designed by Thomas Penson the Younger in 1852. It is Grade II listed. It is built high on a sloping site, from which, it is said, you can see four counties. Running downwards are the old Cemetery Road on one side and Stryt Las on the other. Between them, on a fine open site, are the older and newer burial grounds. They are a tribute to a community that cares about its heritage and its predecessors: visitors come every day, fresh flowers are laid, and dozens of newer headstones display chiselling in gold on Italian marble.

Penson (*see* entry 16) designed a Norman church to a cruciform plan with slate roofs. There are nave transepts, a chancel, a three-stage bell tower and a rounded wooden pulpit. It has a nave with four bays, each with a broad window with triple windows to the north and south. A corbel runs across the building outside, incorporating human and animal heads. It is an excellent example of Romanesque Revival church design.

In 2003 this church closed because it needed £300,000 for repairs. Rhos has three churches (including this one) and had at one time as many as nineteen chapels, many of which have now closed.

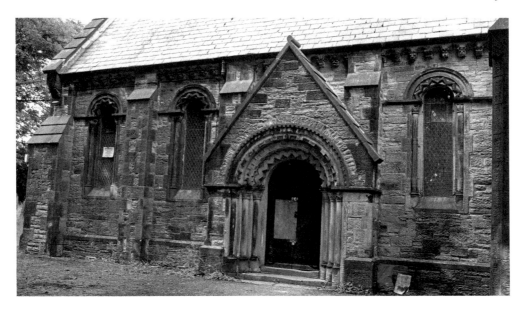

Church of St John the Evangelist, Rhos.

The original entrance on Church Road is in a state of neglect: the archway needs cleaning and repointing and the outward gate is secured with a lock. Inside the grounds there are overgrown bushes, and many tall trees obscure a view of Wrexham and the Cheshire Plain from the lower side. The church is currently for sale.

24. Rossett Mill

DID YOU KNOW ?

The great artist Turner once visited Wrexham.

Rossett Mill is on 10 acres of land and has two modern coach houses. It has been converted to residential accommodation and is Grade II listed.

It is dated 1588 and was historically known as Marford Mill. It is of timber-frame construction on a stone base and was later extended in 1661 and during the 1820s. The great artist J. M. W. Turner sketched the building in 1795.

Across the road is a building that was a maternity hospital named Trevalyn after the Second World War. Many residents of the larger Wrexham area gave birth there. Those that

Rossett Mill.

were born there have Rossett recorded as their place of birth, rather than Wrexham. In its previous form, Marford Hall was built around 1086 and is mentioned in the Domesday Book. The village contains St Peter's Well; its sacred waters are alleged to be a cure for eye and limb ailments.

Rossett has a population of around 3,200. It is 7 miles from Chester.

25. North & South Wales Bank (est. 1836)

DID YOU KNOW ?

The present HSBC Bank has its origins in Liverpool in the early nineteenth century.

In Wrexham's High Street stands an imposing building fronted by four sets of double columns. This was originally the home of the North & South Wales Bank, which had its first outlet in Liverpool. In 1908 the 'Wales bank' amalgamated with the Midland Bank, and subsequently its business and branches used this name. This was one of the largest provincial banks, with over 100 branches.

The bank envisaged a network of branches throughout Wales, which was ambitious considering the general absence of railways. George Rae was general manager and

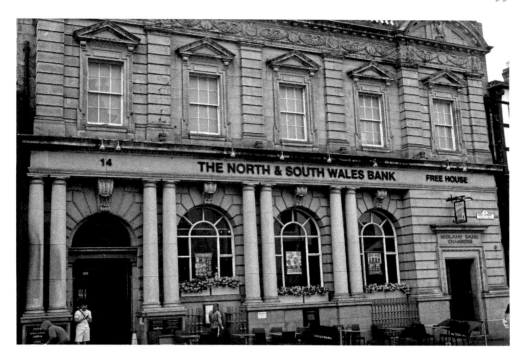

Old Bank, High Street.

chairman. In 1836 an expansion of the bank saw branches open in Wrexham, Mold, Chester, Ruthin, and Oswestry among others. Efficiency of bookkeeping, recording systems and training of staff received high priority, unlike other banks, and a good reputation ensued.

26. Leather

DID YOU KNOW ?

The eleventh edition of *Encyclopaedia Britannica* was bound in Wrexham leather.

Agricultural facilities and animal skins were freely available, and turning these into usable leather involved tanning. Cattle horns were shaped into buttons and combs.

By the 1890s two leather factories existed in Wrexham. In one of these, in 1858, J. Meredith Jones and Charles Rocke went into partnership in order to develop the Cambrian Leather Works in Salop Road. At one point the business employed over 200 people, and many of the machines were invented by Jones.

Site of the leatherworks.

J. Meredith Jones & Sons manufactured high-quality leather for purses, boots, gloves, hats etc. There was a display at the Tokyo International Fair in 1907. Gomshall Industries purchased the factory site in 1946, whose chamois leather sold well in the USA. It had success when it received an order for over a million skins to be used in binding the eleventh edition of *Encyclopaedia Britannica*. In 1968/9 annual sales exceeded £2 million and the works produced over 10 million square feet of leather per year. In the late 1960s Wrexham soft leather went into the making of the fashion item hot pants.

The Cambrian Leather Works closed in 1975.

27. The Minera Lead Works

DID YOU KNOW ?

In the late nineteenth century, over 1,000 people were employed in lead mining in north-east Wales.

Lead was mined in north-east Wales by the Romans, and was exported from Deeside at Chester. After various attempts to make lead mining profitable, new methods of production were applied and Minera's lead mines were reopened. In 1850, a new company took over.

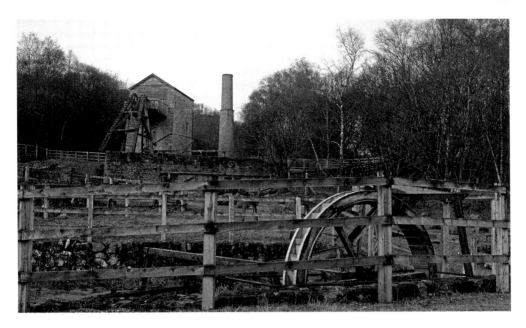

Minera lead works.

Soon, rich deposits of lead were discovered and for the following thirty years, huge profits were made. At this time, some 1,000 people were employed in the county in lead mining. However, the deposits were becoming depleted, and US and Australian imports replaced the home market. The Minera lead mine closed in 1914.

The current Minera has a population of around 1,600 and abuts Coedpoeth. The name dates back to 1339 and links with the Latin term for 'mine' or 'ore'. During the reign of Edward I, miners from Minera went to Cornwall to work in the tin mines. Three limekilns were recorded in operation in Minera in 1620.

28. Offa's Dyke

DID YOU KNOW ?

Offa's Dyke runs through Aberderfyn, which is a part of Rhos.

Offa's Dyke runs through the western outskirts of Ruabon, through the Gardden area, and through the Rho/Johnstown area, west of Wrexham town. It can be clearly seen three-quarters of a mile west of Bersham and crosses the lower part of Aberderfyn Road.

Offa's Dyke in trees, Gardden Hill.

It is a mound of earth and stone, built in the late eighth century (the dates AD 779 and 790 are sometimes cited) as a western marker of the boundary between Saxon Mercia and Celtic Wales. It runs from Chepstow in the south to Prestatyn on the north coast, and is some 177 miles long. It is named after Offa, King of Mercia, and is much longer than Wat's Dyke. It runs through the west side of Chirk Castle.

29. Hanmer

DID YOU KNOW ?

The famous poet R. S. Thomas was a curate here in the early 1940s.

Hanmer is a small attractive village to the south of Wrexham County Borough with a population of around 660. It is on the northern end of the Shropshire Lake District – a series of meres. There was an early reference to the village in 1110. It has its own dialect, which was reported in the Survey of English Dialects, the only place in North Wales to be included.

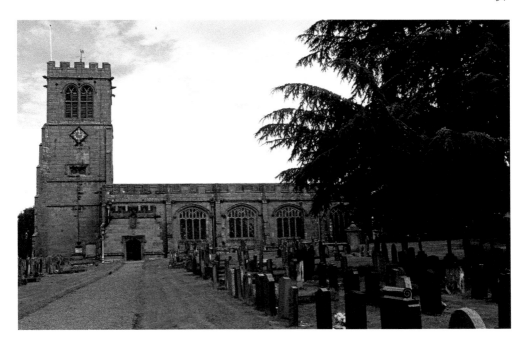

Hanmer Church.

Margaret Hanmer lived here, a daughter of Sir David Hanmer. She married Owain Glyndwr, the Welsh patriot who fought for self-government for Wales, in 1383.

The book *Bad Blood* by Lorna Sage, winner of the Whitbread Biography Award in 2000, is set here. Sage grew up in Hanmer during the 1940s and '50s and her grandfather was vicar of St Chad's Parish Church.

30. Brymbo's Iron and Steel

In the 1880s the iron and steel business of Brymbo became reinvigorated largely through the efforts of J. H. Darby (1856–1919) and Peter Williams (1855–1919). Darby was a descendant of Abraham Darby, the ironmaster and son of W. H. Darby, who with C. E. Darby and Henry Roberts re-established the ironworks in Brymbo.

J. H. Darby was an expert metallurgist and chemist who was manager of the Brymbo ironworks and, afterwards, the steelworks. He was responsible for introducing many new manufacturing methods. In 1885 he and Peter Williams introduced the basic open-hearth process of producing steel. Darby visited Belgium and on his return he installed at Brymbo the by-products coke oven, known as the Semet-Solvay system, the first of its kind in Great Britain. He was the first to use a basic lined gas-heated metal mixer. He also discovered a special method of carburing steel – the quality of steel depends on the quantity of carbon

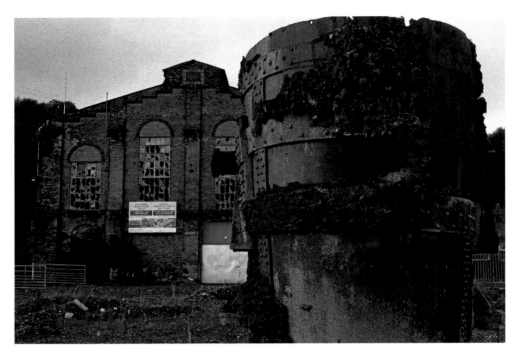

Remains of Brymbo iron/steelworks.

it contains. He received the Bessemer Gold Medal in 1912, and in 1914 he became advisor to steel businesses across the UK.

Peter Williams was born in Pentre Broughton, starting work at twelve years of age, firstly in coal and then in Brymbo ironworks. He worked his way up to become managing director of Brymbo Steelworks. In 1884 he went to Russia to study the basic open-hearth system of making steel, which was introduced to Brymbo in 1885, and he designed the new plant.

31. Rhosllanerchrugog

DID YOU KNOW ?

Rhos is the largest village in Wales.

Its name in Welsh is complex: it connects with moorland and heather. It is no exaggeration to say that all over Wales, Rhos (as it is commonly called) is famous for its music and teachers. It has a special spirit and places high value on educational experience

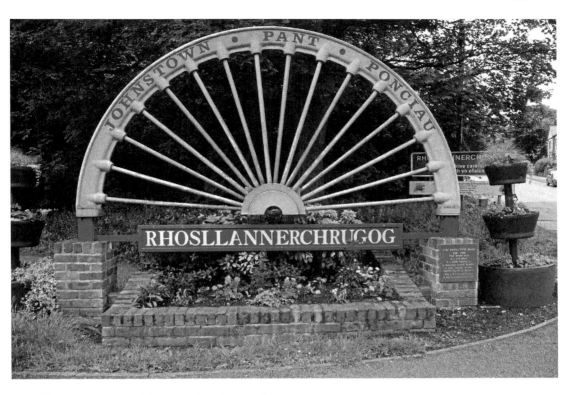

Rhosllanerchrugog (also spelt Rhosllannerchrugog).

and advancement. It was strongly caught up in the invigoration of Welsh Nonconformity, building chapels in quantity in the second half of the nineteenth century. There were over fifteen such buildings in the community, with Baptist ones being the most numerous, many of which have now closed.

The nineteenth-century expansion of coal mining brought the Bersham and Hafod collieries to high production. Situated around a mile to the east of Rhos, large numbers of men worked in them; this was the lifeblood of the economy of the village. It was said that on some days, after walking to work, the miners were sent home as there was no work available.

Miss World in 1963, Rosemarie Frankland, was born in the village and is buried there.

32. Wat's Dyke

There are two old dykes running through the Wrexham area. Wat's Dyke is considered to be the older of the two. It runs for some 40 miles south from the River Dee estuary, passing to the east of Oswestry and ceasing in north-west Shropshire.

Sometimes it runs close to Offa's Dyke, being not more than 3 miles away. The dyke faces Wales, with its ditch on the western side, seemingly to protect English lands to the east. The dyke is placed so that it gives clear views to the west – the ramparts are 2 metres tall – to allow warriors to see approaching troops.

Excavations near Oswestry have uncovered charcoal that was dated to the fifth and sixth centuries. This dates Wat's Dyke to the post-Roman period. There is evidence to show that the area of Mercia that had Wat's Dyke as part of its western border was at this time a well-organised kingdom.

Archaeological investigations by Queen's University, Belfast, dated the construction of Wat's Dyke at between AD 411 and 561. This places it some 300 years before Offa's Dyke.

Old drawing depicting the building of Wat's Dyke.

33. Marford

You cannot misidentify Marford because it has very distinctive architecture. It is located in the north-east of the Wrexham County Borough area, near the Wales–England border. You can see Chester Town Hall and the cathedral from here.

Its name stems from 'mere', meaning boundary. At the time of the Domesday Book, it was part of the Lordship of Bromfield but was later incorporated into Powys-Fadog. A neighbouring area known as Hoseley was mentioned in the Domesday Book.

The Trevalyn Hall estate developed the village, building houses in a Gothic-derived style. The buildings weredistinctive for their special windows. Most were built in 1780–1800 and were originally roofed in thatch. Local folk tales tell of a ghost that is said to be Margaret Blackbourne of Rofft Hall, who was murdered in 1715 by her husband George, the steward of the estate. Locals now speak of 'Lady Blackbird', who taps at windows.

A cottage in Marford.

The Trevor Arms is at the bottom of Marford Hill. The name is derived from the landowning family of Trevalyn Hall: the Trevors. According to local stories, there are ghosts here – a cavalier and a woman killed by her cheating husband.

A nearby quarry was opened in 1927 to provide material for the construction of the first Mersey Tunnel. Some rare species grow here and the area was purchased in 1990 by the North Wales Wildlife Trust.

34. Wrexham in the Bronze Age

The colonisation of the British Isles in the third millennium BC saw agriculture, stock raising, the grinding of stone implements and the creation of pottery introduced in the higher areas. In the rest of Wales, this period saw cromlech and chambered tombs introduced.

However, in Wrexham it is not until the Bronze Age, in the second millennium BC, that we see signs of early habitation. There are cairns and tumuli as burial places to the west of the town from the period known as the Beaker times. Circular mounds made of stone and earth range from 20 to 60 feet in diameter and up to 7 feet in height. Some have evidence of a stone burial chamber at its centre. They lie on higher ground, usually over

North side of Fairy Road, Wrexham.

the 1,000-foot contour. In Wrexham itself, two tumuli have been discovered. One was at Hillbury, between Percy Road and Sontley Road, where a cist was found containing an urn and burnt bones (the urn here contained human remains). The second tumulus is the 'Fairy Mound', on the north side of Fairy Road. Human bones and fragments of pottery were found here, including parts of a drinking cup.

35. Hafod Colliery

This was one of the four largest collieries in the central Wrexham area. It was opened in 1867 after an incident of flooding in at Ruabon colliery, which was connected underground with Bersham colliery. Two shafts were involved and the upshaft was 1,830 feet.

In 1896, Hafod-y-Bwch colliery (as it was then called) employed over 1,200 men. In 1938 it reached its employment peak of 1,668. Employment in Rhos depended on Hafod colliery for some seventy-five years. Production stopped in March 1968. Some miners got new jobs at Gresford and Bersham, but many became unemployed. Around 200 men were retained to recover underground equipment before the shafts were sealed and the surface buildings were entirely demolished. Nothing of the original pit remains today.

Footpath at Hafod colliery site.

36. Llyr Williams, Pianist

Born in 1976 in Pentre Bychan, to parents who introduced him to opera at an early age, Llyr Williams attended performances at Llandudno and Manchester. He attended Ysgol Hooson, Rhos, and then Ysgol Morgan Llwyd, Wrexham, reading music at Queen's College, Oxford, from 1988 to 1995, finishing with a first. He attended the Royal Academy of Music and received its highest award, the Diploma.

He said that he played at his piano for six hours a day, and in 2004 he received an award to replace its mechanics. In 2007 he performed at eleven venues in the USA on a tour with the BBC National Orchestra of Wales. He is official accompanist for the Cardiff Singer of the World competition and is currently undertaking a Beethoven piano sonata cycle at the Wigmore Hall, spread over three seasons. He appeared in 2016/17 at the Washington Performing Arts and Portland Piano International.

Williams continues to be in demand in classical musical venues all over the world, and is represented by Victoria Rowsell Artistic Management.

Llyr Williams, pianist.

37. Ruabon in the Early Days

The area between the Welsh hills and the English border has experienced formal agriculture for over a thousand years. For some 3,000 years people have lived in the Ruabon area. In 1400 BC there were settlements here, according to archaeological finds. These were made in Cleveland Street, now in the centre of the town, and further evidence was found when workmen digging drains found a funeral cist containing human remains. Then in 1917 local schoolchildren working in the school gardens discovered a Bronze Age mound known as a round barrow. The hill fort known as 'Y Gardden' was a place of Iron Age settlement, dated around 450 BC. It sits 585 feet above sea level and would have been a defensive location. The local tribe were the Deceangli, who faced the Romans in AD 55. The Romans used the Wrexham area for crop growth, supplying the 20th Legion based at Chester.

The earthworks of Offa and Wat run through the Ruabon area; these are still act as boundaries, with the churches of St Mary and St Mabon standing between them. Hafod and Rhuallt names started in the area before the thirteenth century.

Tatham Farm is close to the site of Offa's Dyke. Close to it is the present Gardden Industrial Estate, on a site previously occupied by the Dennis tile factory. The iron trolley fronting it is a relic of the days when a small-gauge railway line ran from Ruabon to Wrexham, for carrying coal and iron.

Gardden Industrial Estate with original goods truck.

38. The Bloody Hand of Chirk

The magnificent iron gates of Chirk Castle were created between 1719 and 1721 by Robert and John Davies of Croes Forge, Bersham. Sir Richard Myddelton paid them 2s a day for their work, with iron taken from Sir Richard's nearby Pont-y-Blew forge.

Their huge size is explained by their original purpose as forecourt gates, with palisades connecting to the castle. The Myddelton coat of arms is incorporated in their original design, with wolves' and eagles' heads. This coat of arms incorporated the red hand, of which there are various stories. One tells of two brothers who were in dispute over the ownership of the castle. They challenged one another to a race, and the first one to touch a distant gate would be the owner. They had the race and as one reached out his hand to touch the gate, the other drew his sword and cut off his hand – the bloody hand. The other then touched the gate and became owner of the castle.

Another story is that the red hand carries a curse. This can only be removed if a prisoner in the castle spends twelve years in the dungeons. A third story involves one of the early Myddeltons wearing a white tunic during a battle. His hand was severed and the image was left in blood on his clothing.

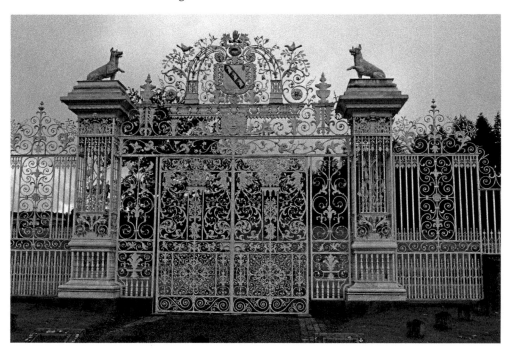

Chirk Castle gates.

39. Erddig House

DID YOU KNOW ?

Erddig House, one of the largest houses in the Wrexham area, never had any mains electricity.

This is an imposing house on the edge of Wrexham town and is now a National Trust property. It enjoys many visitors to its house, outbuildings and gardens. The house was built in 1684 for Josiah Edisbury, the High Sheriff of Denbighshire. Simon Yorke (d. 1767) inherited the property and subsequently it passed down the Yorke family, where it remained until March 1973, when it was given to the National Trust. There had been a disaster five years earlier when a shaft from the nearby Bersham colliery collapsed, causing subsidence of 5 feet. This caused considerable damage to the structure. The National Coal Board paid £120,000 for underpinning and repairs. The 63 acres of parkland was sold for £995,000, which paid for restoration work at the house.

One notable feature of the house is its gallery of portraits of workers and owners of the house, with photographs and prose/verse accounts, starting in the 1790s. The Yorke

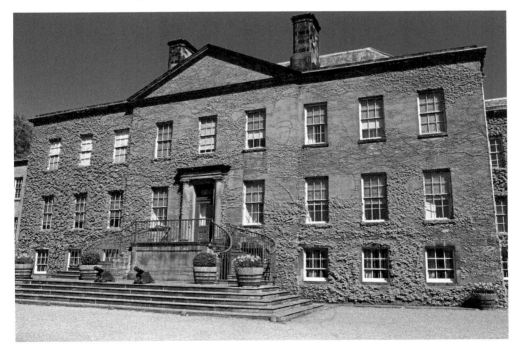

Erddig House.

family were great hoarders and had in their collection an assortment of eighteenth-century furniture. There is Chinese wallpaper in the State Bedroom.

The outbuildings are of particular interest, with Midden Yard and Stable Yard. The house at base includes a laundry, bakehouse, kitchen and scullery. These are in good preserved condition and allow a rare view of an eighteenth-century working gentleman's residence with extensive farmland.

The walled garden is also a unique feature. It contains rare fruit trees, a canal, a pond and a collection of ivy plants. The railings and gates were manufactured by the Davies Brothers of nearby Bersham. There is a remarkable cascade known as 'The Cup and Saucer', supplied by water from the nearby river, which is pumped uphill by a hydraulic ram.

There was never mains electricity in Erddig, the last of the Yorke line having used a television set that was powered by a generator. A steam engine supplied power to the sawmill.

There is a room in the house with wall illustrations featuring the coats of arms of North Wales families. Philip Yorke (1743–1804) was the author of the important volume *Royal Tribes of Wales*.

40. The Welsh Language in Wrexham County Borough

The 'secret' here is that the Welsh language is in decline. The 2011 census gave the result that 16,659 people in Wrexham County Borough spoke Welsh, which is 12.9 per cent of the population. In 2001 the sum was 18,102, or 14 per cent of the population. So, over ten

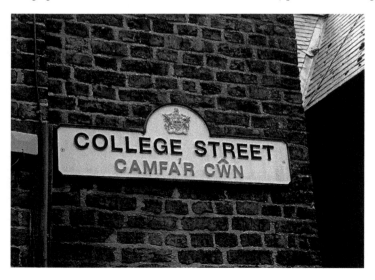

College Street, Wrexham – the dog's stile in Welsh.

yearsthere was a drop of 1.7 per cent. The latest census records that the highest number of Welsh speakers were in the Ceiriog Valley (31.2 per cent), Ponciau (28.2 per cent) and Pant (26.6 per cent). The lowest Welsh-speaking area was to the east, nearer the English border.

Since 2001 there has been a small increase in Welsh-speaking in fifteen electoral divisions, the largest increases being in Holt and Gwersyllt.

In the twenty to forty age group, only 9.6 per cent of Wrexham County Borough Council residents were recorded in 2011 as Welsh speakers. In the county borough there are seven Welsh medium junior schools. Ysgol Morgan Llwyd in Wrexham is a Welsh medium secondary school with over 800 pupils. Statistical analysis reveals that the census results for young people aged ten to fourteen in Wrexham County Borough are unreliable, owing to parents misrepresenting their children's abilities in the language.

41. Telford's Chirk Aqueduct

Another spectacular bridge by the amazing Telford. The aqueduct carries the Llangollen Canal across the Ceiriog Valley and spans the Wales–England border. It was built by masons with a trough construction in cast iron. Its length is 710 feet, with a towpath on the eastern side. At 70 feet high, it is traversable by narrowboats and has ten spans. It is Grade II listed and was a forerunner of the Pontcysyllte Aqueduct.

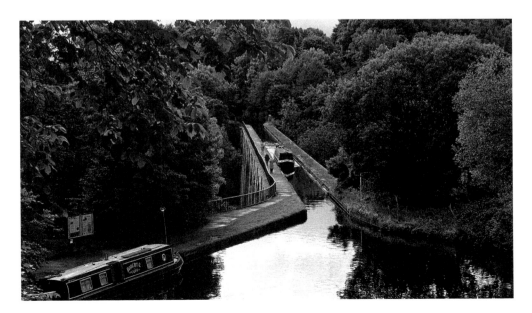

Chirk Aqueduct.

Designed by Thomas Telford, it was completed in 1801. A tunnel at the north end allowed the canal to continue towards Llangollen. Close to it is the railway viaduct on the Ceiriog Valley side. This was built higher than the Chirk Aqueduct, showing the superiority of rail transport over water transport.

42. Erbistock Hall

Situated in the local government community of Erbistock, part of Wrexham County Borough, close to the River Dee, this site is not open to the public. It is in the Cadw Register of Landscape Parks and Gardens of Special Historic Interest in Wales – listed as Grade II. The Welsh Historic Gardens Trust is also associated with it.

The house was built in 1720 for the Wynn family of Wynnstay. Its notable dovecote was built between 1700 and 1737, with a conical slate roof. The weathervane at the top of the roof is dated 1737 and is thought to feature 700 nesting holes. The house was originally three storeys high but it was later reduced to two.

The gardens are partly terraced and date from the early eighteenth century. There is well-preserved yew hedging and topiary, which were present in the early nineteenth century.

River Dee, close to Erbistock Hall.

43. Erbistock

Erbistock, a village on the southern edge of the Wrexham County Borough, had a population of 383 at the 2011 census. It was one of the territories of the Lordship of Bramfield and is mentioned in the Domesday Book. The Wrexham historian A. F. Palmer has noted its association with extending English control at the border by Edward I. In 1300 a writ was issued to the justice of Chester detailing the king's lands at Erbistock.

The original parish church was dedicated to St Erbin from the thirteenth century, but the present church is from the nineteenth century and is dedicated to St Hilary. The church contains an eighteenth-century chandelier and a font bowl that is thought to be Norman in origin. The village name is derived from 'the stockade ford of Erbin'.

Erbistock has two popular pubs: The Cross Foxes on Overton Bridge dates from 1748 and was built by the Wynn family for its workers – the crossed foxes image was part of the insignia of the Wynn family; the other is The Boat Inn, which sits squarely beside the River Dee.

The Boat, Erbistock.

44. Tenters Square and Lane

DID YOU KNOW ?

The expression 'to be on tenterhooks' derives from cloth manufacturing.

Situated on the edge of Bellevue Park on the A5157, Bridge Street (postcode LL13 7LF), the name derives from the wool trade. Sheep farming was widespread in North Wales and spinning wheels became common in farms and homes. Homespun and home-dyed cloth was worn – soering and carding of wool was common. Weavers moved from farm to farm, making cloth from yarn. Fulling mills existed to clean wool and clear it of natural oils; it would be beaten, shrunk and thickened and afterwards stretched out and dried in the open air. This was suspended from and held together by tenterhooks.

Wrexham had a substantial wool trade, particularly in flannel, a thick, cruder fabric used for soldiers' uniforms, although Shrewsbury competed for the business.

Site of Tenters Square (on the left), Wrexham.

45. Wrexham: A Market Town

As the largest town in North Wales, Wrexham had the most trades. Farmers and craftsmen would come here to sell their wares, farm implements were replaced and tea, tablecloths, sugar, wines and spirits etc. were purchased. Weavers were numerous, getting their yarn from nearby cottages. At the close of the sixteenth century, flax weavers, crepe weavers and flax dressers worked here – flax was grown in the surrounding fields. The skin trades flourished: leather breeches were made along with saddles and gloves. Felt was made from the hair of animals to make hats. Buttons and combs were made from horn. Bersham foundry supplied metal for the making of swords, buckles, nails, locks and needles.

In the seventeenth century, Wrexham had two markets a week and three annual fairs, each held for twelve days in March, June and September. Merchants from Birmingham erected stalls in the open air to show and sell their goods. The Eastertide funfair is a relic of this. Many residents recall the 'Beast Market', which has since been built upon.

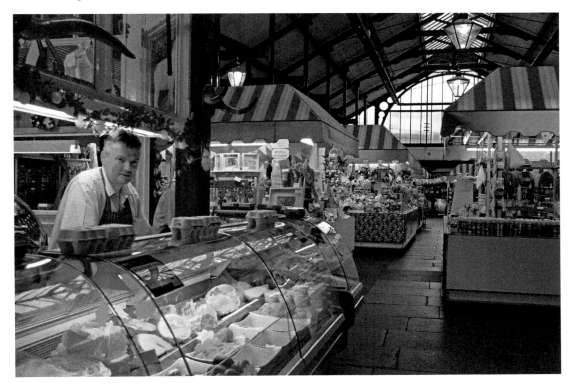

The Butchers Market.

46. Ruabon's Industry

In the 2011 census Ruabon had 4,274 inhabitants. Its name derives from 'rhiw' in Welsh, meaning hill, and St Mabon, to which the original church was dedicated. In the census, fewer than 14 per cent could speak the Welsh language.

In his famous book *Wild Wales*, George Borrow wrote a vivid account of local ironworks:

I ascended a hill, from the top of which I looked down in to a smoky valley. I descended, passing a great many collieries, in which I observed grimy men working amidst smoke and flame. At the bottom of the hill, near a bridge, I turned round. A ridge to the east particularly struck my attention; it was covered with dusky edifices, from which proceeded thundering sounds, and puffs of smoke. A woman passed me, going towards Rhiwabon; I pointed to the ridge and asked its name; I spoke in English. The woman shook her head and replied '*Dim Saesneg*' ('no English'). 'That is how it should be,' I said to myself. 'Now I feel I AM in Wales.

Example of building with Ruabon brick and tile, Fairy Road, Wrexham.

The growth of the town is due to the large deposits of iron, coal and clay. For two centuries, coal dominated. Pits existed in Rhos, some distance to the north, including Ponciau, Aberderfyn. These ceased production in 1846 when there was severe flooding. The very large Hafod and Bersham collieries, which are at the edge of Johnstown, were sunk later, in the 1860s.

Iron was widely worked in the area at Acrefair and Cefn Mawr as well as the town itself. Zinc was extracted at Wynn Hall. Most of the mineral wealth was carried by canal over the Pontcysyllte Aqueduct on the Shropshire Union Canal, until the railway reached Ruabon in 1855.

Three clay companies operated in the area. The Ruabon Brick & Tera Cotta Works (known in Welsh as *Gwaith Jinks*) was founded by the Hague family of Gardden and managed by Henry Jinks. It produced bricks, chimney pots, finials, cornices and encaustic tiles. It was taken over by the Dennis company in the 1960s but later closed. Many houses in Wrexham feature Ruabon brick and tiles, some with attractive designs including turrets.

47. Overton, of the 'English Enclave'

DID YOU KNOW ?

In the centre of Overton there is a listed telephone kiosk.

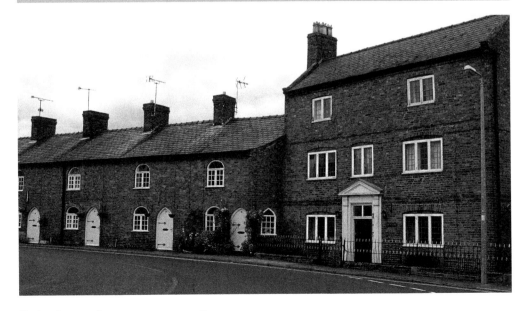

Early nineteenth-century cottages, Overton.

What can be dubbed 'the English enclave' is an area of Wrexham County Borough to the south of Wrexham town. It encompasses Eyton, Marchwiel, Bangor-on-Dee and points south to the English border, including, notably, Overton.

Even though Eyton is close to Johnstown, which is part of Rhos with its industrial heritage, it is different in economy and culture. Fields with rich pastureland, farms with extensive outbuildings, well-trimmed hedges and copses feature, with many holdings having remained in the same families for many generations. There are some well-known landowning families. There is hardly any Welsh spoken here, and the setting is reminiscent of Cheshire and Shropshire.

Overton is a long-established village with some tall brick buildings in its high street. According to the 2011 census it has a population of 1,382. It is 7 miles from central Wrexham and 22 miles from Chester and Shrewsbury. In 1294 it was the scene of a battle between the Welsh forces of Madog ap Llywelyn and the English forces of Edward I.

The Church of St Mary the Virgin is famous for its twenty-one yew trees. These are featured in the old rhyme,

> Pistyll Rhaeder and Wrexham steeple,
> Snowdon's mountain with its people,
> Overton yew trees, St Winifride wells,
> Llangollen bridge and Gresford bells.

These trees are thought to be 1,500 years old. In 1292 Edward I presented a charter to the village and in 1992 Elizabeth II visited and planted a new yew tree.

The old telephone box is listed, and the village centre is a conservation area.

48. The Horse & Jockey

DID YOU KNOW ?

This Wrexham inn was named after champion jockey Fred Archer.

In Hope Street, this thatched-roofed low building is out of character with the rest of Wrexham's centre. It possibly dates back to the sixteenth century. In the seventeenth century, this was three premises, part of which was an inn called The Colliers. In 1868 one pub was created with the name the Horse & Jockey in honour of Fred Archer (1857–86). He is regarded as one of the greatest jockeys. He committed suicide at the age of twenty-nine after the death of his first child and his wife. He had more than 2,700 wins, was champion jockey thirteen times and was unusually tall for a jockey. The pub sign shows a portrait of him.

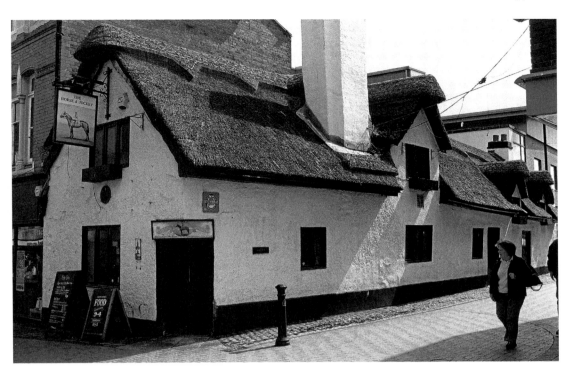

The Horse & Jockey, Wrexham.

The Wrexham Lager Co. bought the building in 1938 and made repairs to prevent it from collapsing. There are tales of a ghost here called George.

49. The Boat at Erbistock

DID YOU KNOW ?

You could once cross the River Dee at Erbistock with the help of a mechanical device.

The Boat is a well-known inn situated in a spectacular position on the banks of the River Dee, in a low building of attractive pale brown stone. It is said that there was a building here in the thirteenth century – the present one dates from 1738. A carriage across the river existed as a chain-operated function and part of this mechanism remains. The Boat is a very popular out-of-town location for drinkers and diners. There is a larger dining room on the upper floor.

Remains of a winding wheel to cross the river at Erbistock.

50. Pant-yr-Ochain

Situated just outside Wrexham, off the Holt Road, this was originally a Tudor house but has been expertly changed into an inn and restaurant. It has wide views of lawns, fields and a lake and is ideal for alfresco dining in the summer.

Its country location makes it very popular with diners and is booked up at Easter and Christmas. The rows of book, timbers and inglenook fireplaces give the inside a special atmosphere where much of the old building from the 1530s has been preserved. Tudor wattle and daub made of woven hazel covered with clay, hay and straw can be seen behind the inglenook fireplace.

A feudal lord named Ochain lived at this site in medieval times. In the nineteenth century, the Cunliffe family, whose wealth derived from the slave trade out of Liverpool, bought and repaired the building. They owned a number of estates in the Wrexham district. Acton Hall was the main seat of the family and Pant-yr-Ochain became a dower house. Their coat of arms, marked 1835, appears on an external wall above the conservatory.

There are stories of ghosts here. People standing at the bar have seen a figure dashing up the stairs, only to disappear, and at night when the building is quiet voices have been heard coming from below.

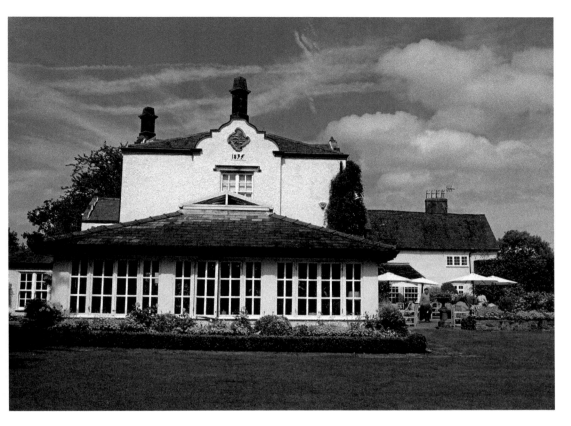

Pant-yr-Ochain, Wrexham.

51. The Great Artist Turner Depicts Wrexham

Joseph Mallord William Turner (1775–1851) visited Wrexham in 1792–93 and again in 1794. He left two pictures, the first of which is a depiction in watercolour on paper of a street scene with the church tower in the background. There are four premises shown, with original windows and gables, in shades of brown. The picture is in the Victoria and Albert Museum, London.

The second work is of graphite on paper, of Wrexham Church from the east, cited as 'drawings made on the Midlands tour'. The drawing, in monochrome only, is of St Giles', showing the tower, roofline, fascia, windows and foreground tree. It is from the Martlock sketchbook. The tower shown dates from the sixteenth century and is of exceptional height – some 135 feet.

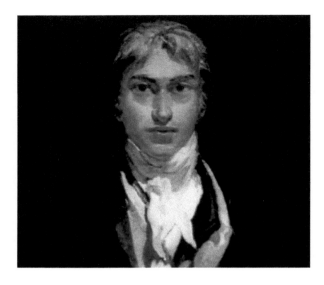

Artist J. M. W. Turner.

52. Lorna Sage

Lorna Sage grew up in Hanmer in the 1940s and '50s, when her grandfather was vicar of St Chad's Church. She is best known for her autobiography *Bad Blood*, an account of problems and disappointments in her family. The book won the Whitbread Biography Award in 2001, a week before she died in London of emphysema, a condition she suffered from for most of her life.

She became pregnant when she was fifteen and was unable to continue her education. However, she won a scholarship to read English at Durham University. She then took an MA at Birmingham University for a thesis on seventeenth-century poetry.

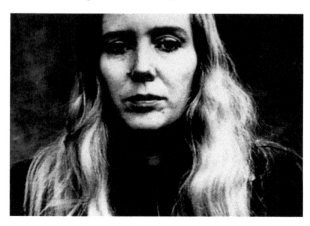

Lorna Sage.

From 1994 she was professor of English at the University of East Anglia, and she edited *The Cambridge Guide to Women's Writing in English* (1999). She contributed reviews to many periodicals, covering authors like Thomas Hardy, Doris Lessing, John Milton and many others.

She had a daughter with Victor Sage, Sharon, born in 1960.

53. Wrexham Football Club

The club goes back to 1864, and is the oldest football club in Wales and the third oldest professional football club in the world. It was founded in the Turf Hotel. In 2017 it was owned by the supporters and had over 4,100 adult members and joint owners. It competes in the National League, the fifth tier of the Football League. They were relegated in 2007/08 after eighty-seven years of Football League membership. A return to the Football League is eagerly anticipated by supporters, many of whom reside across North Wales.

In the past Wrexham FC has had many League Cup successful runs, the most notable being in 1992 when they beat Arsenal. The Racecourse ground is the world's oldest stadium that continues to house international games. The ground has a capacity of 15,500 and is owned by Glyndŵr University.

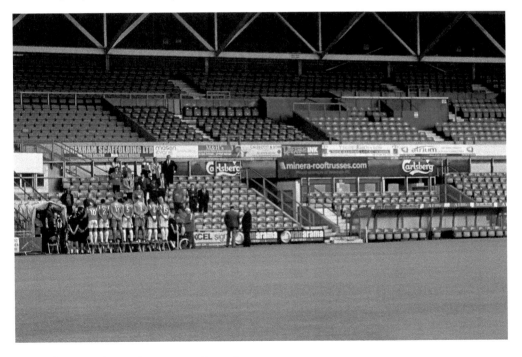

Football at Wrexham's Racecourse Ground.

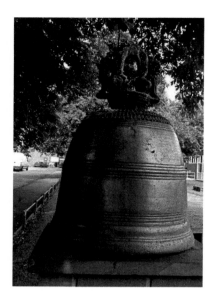

The Burma Bell.

54. The Burma Bell

Now situated near the war memorial at Bodhyfryd, this bell was brought back from a Buddist temple in Mandalay in 1885 when 730 men and seventeen officers returned from Calcutta. Two years later 309 men and six officers reached Lucknow with eighty-seven dead from disease and 341 invalided. Only four had been killed by the enemy. The statement 'Burma 1885–7' was added to the regiment's colours by Queen Victoria. (Thanks to Wrexham History)

55. Clockmakers in Wrexham

There is a long history of clock and watchmakers in Wrexham, where at least twenty have been identified. Early clocks were owned by the wealthy including Sir John Trevor, who had a clock in the 1580s. The clock on the tower at St Giles' Church originated in the early seventeenth century.

From *c.* 1650 clockmakers expanded in Wrexham, encouraged by well-off landowners including the Wynns, Lloyds and Yorkes. The lead mines at Minera would supply lead weights, and local cabinetmakers created oak for the cases of grandfather clocks, which were part of domestic furniture. Wrexham's clockmakers imported metal parts from Birmingham. Families

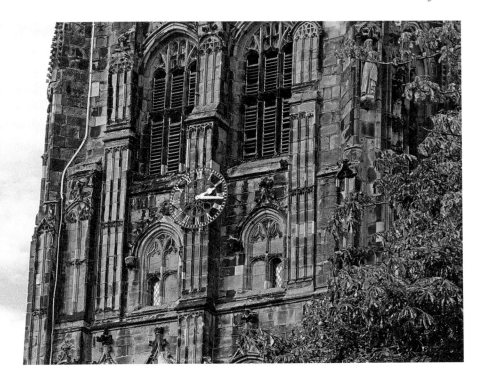

Clock on St Giles' Church.

passed down their skills, including the Ratcliffes, who were working here in the mid-eighteenth century, and also the Hampsons and Fernals. Humphrey and William Maysmore were working in Town Hill in the early eighteenth century. (Thanks to Wrexham History)

56. The Bigamist from Rhos

Benjamin Jarvis was a miner and not in good health – like most miners. He was said to be blind, but was apparently able to distinguish between one person and another. Ponciau became Ponkey in some quarters and it had a Registry Office, where on 26 August 1854 our man married Sarah Evans (legally).

However, all was not well and Jarvis took to an old custom, that of selling your wife. He asked 1s 2d for her and she was transferred to his friend John Jones; however, apparently she had already left him and had a child by John Jones.

Benjamin Jarvis had enough eyesight to observe one person called Puah Roberts, from Rhos. The Banns were published and on the 6 July 1857 they were 'married' at St Mary's, Ruabon. Married comes in inverted commas because our man Jarvis was already married – his 1s 2d was wasted.

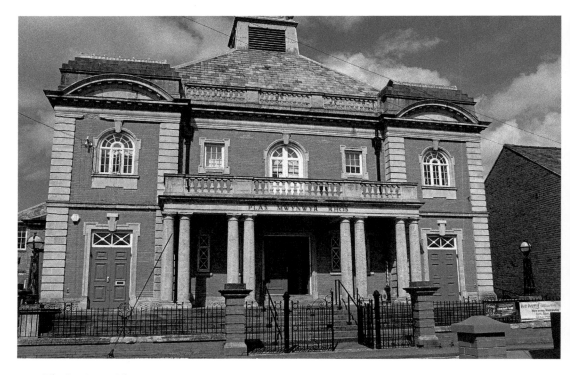

The Institute, Rhos.

Word spread and the police came in. PC Stant arrested Ben on 11 July 1857. Ruthin Assizes Court came into play. A warrant was made to apprehend his first wife, Sarah, for bigamy but no evidence was presented to prove that she had married John Jones.

On 27 July 1857, Benjamin Jarvis was sentenced to one month's imprisonment for the crime of bigamy. (Thanks to Wrexham History)

57. The Davies Brothers of Ruabon

DID YOU KNOW ?

Some of the finest wrought ironwork in Britain was created at Bersham.

The Davies Brothers of Ruabon is the name they are known by, but the brothers worked at the Croes Foel Forge, Bersham, Wrexham. They were a father and two sons: Huw Davies (d.

Davies Brothers gates, St Giles' Church.

1702), Robert (1675–1748) and John (1682–1755). There were two other sons in the family and six daughters.

These were no ordinary local artisans. They created work in wrought iron to a European style and quality. Robert is said to have worked in collaboration with the great French wrought-ironsmith Jean Tijoul and Robert Bakewell of Derby was another co-worker.

Examples of their work still survive in country homes and churchyards in north-east Wales and along the Wales–England border. A screen and gate known as White Gates is at Leeswood Hall, Flintshire, described as one of the finest in the UK. Pevsner described the work of the Davies Brothers as 'miraculous'. Among their works are the Golden Gate at Eaton Hall, gates at Erddig Hall, St Giles', and at St Peter's, Ruthin.

58. The Odeon Building, Brook Street

One of Wrexham's most distinctive buildings, with a splendid spacious interior, the Odeon was built to be operated as a cinema by the Oscar Deutsch chain of cinemas. It opened in March 1937, showing *Song of Freedom* starring Paul Robeson.

The design is by architect Harry Weedon, in a typical art deco style. The façade is cream faiance tiles, with a slab tower. It had a large auditorium with 958 seats in the stalls and 288 in the balcony. On each side of the proscenium opening there were six decorative panels.

The old Odeon building, Brook Street.

It closed as a cinema in May 1976. The last film to be shown was *The Man Who Would be King* starring Sean Connery. Mecca pulled out of the building in May 1999, and various businesses have occupied it since then.

59. Canals and Heavy Industry

The Ellesmere Canal was opened in 1805 and served the iron industry, proving useful to Ruabon. The canal joined the Mersey with the Severn. Telford created two aqueducts for it, one at Pontcysyllte and the other at Chirk. Two local men took the business forward: Thomas Jones of Llanerchrugog Hall and Edward Lloyd Rowlands of Plas Bennion. Under them, the iron industry of Ruabon, Cefn and Acrefair flourished. Since 1809 Thomas Jones had taken over the Bersham foundry and the Abenbury forge, and erected furnaces at Ponciau and Llwyneinion. Rowlands owned two blast furnaces at Acrefair, developed a rolling mill and eighteen pudding furnaces and had thirty coal pits working in the area. After 1815, demand fell and there was financial crisis. In this area all the principal activities – mining, smelting, refining, puddling and rolling – were working together, and they had the advantage of carriage by canal.

By the 1840s, deposits of iron ore were becoming exhausted and steel was replacing iron as a medium for locomotive manufacturing, shipbuilding etc., and the Ruabon district was not up to supplying it. However, alone, the Brymbo plant created steel in significant quantity. In 1939 it closed down for many years.

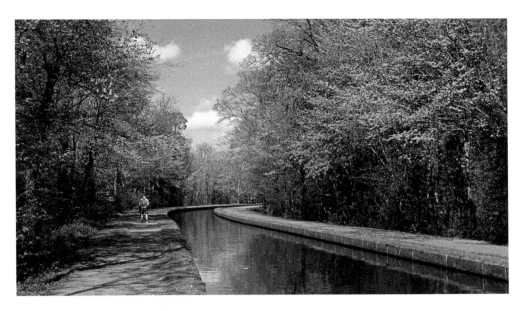

Llangollen Canal, Froncysyllte.

The Llangollen Canal links Wales and England, and from Llangollen this navigable waterway stretches to Harleston in south Cheshire, via Ellesmere. In 2009, an 11-mile section was declared a UNESCO World Heritage Site. This waterway was built when work to complete the Ellesmere Canal ceased in the early nineteenth century. The canal was meant to connect Liverpool with the West Midlands, but was never completed.

60. Glyndŵr University

DID YOU KNOW ?

A significant number of young people come to Wrexham from eastern countries to study.

Glyndŵr University has campuses in Wrexham, Northop and St Asaph. It offers both undergraduate and graduate degrees and has close to 7,000 students. It was granted full university status in 2008. Its name is derived from the medieval Welsh prince Owain Glyndwr, who first suggested a university for Wales in the early fifteenth century. The university's origins date back to 1887, with the establishment of the Wrexham School of Science and Art. It became the North East Wales Institute of Higher Education in 1975. In 1993 NEWI became an associate member of the University of Wales.

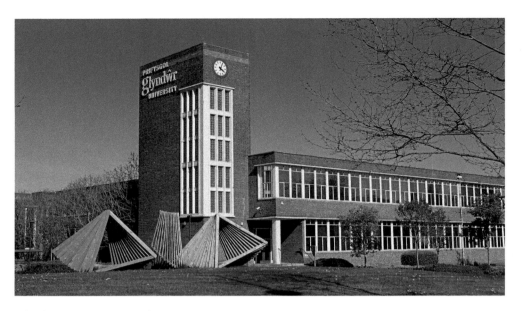

Glyndŵr University, Wrexham.

Many international students are sponsored, especially from India and other parts of the Far East, with engineering a favoured subject. Art and design courses are offered at the Regent Street site, near the town centre. This was named the best place to study art in Wales in the *Guardian* University League tables in 2017, and was marked twelfth among all UK universities. The institution received a mark of 92 per cent for graduate employment. The university includes higher education provision of the Welsh College of Horticulture in Northop, with 96 acres of rural land.

In 2011 the university acquired the Racecourse Ground, the home of Wrexham Football Club.

61. Wrexham's Two Indoor Markets

There are two indoor markets in Wrexham: the General Market in Henblas Street (1879) and the Butchers Market on High Street (1848). Henblas Street was the heart of nineteenth-century Wrexham. It had a mock-Tudor building housing the Vegetable Market, which was, very unfortunately, demolished in 1992. The present Butchers Market has a splendid entrance on High Street. It was the work of the highly talented architect Thomas Penson the Younger. It is described in Hubbard's Clwyd book as 'a frontage to the High Street in unmistakable and cheerful Neo-Jacobean. Shaped and finial gables, pedimented, mullioned and transomed windows and an oriel over the entrance arch'. The Pensons, father and son, also designed the military barracks (now the museum) on Regent Street, and the then British School on Brook Street. Their neo-Jacobean style is now appreciated and valued.

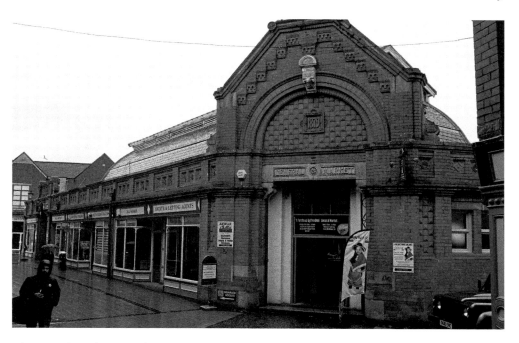

The second market, Wrexham.

A large room sits on the first floor of the Butchers Market. The construction was originally dispraised, the idea being that butchers had always sold their wares in the streets and would never go indoors. However, the market here was an immediate trading success, and people have loved it ever since.

62. County Buildings, Home of Wrexham's Museum

DID YOU KNOW ?

The present Wrexham Museum building was once an army headquarters.

Finally, this splendid building in Regent Street has found a suitable use. The museum is well worth a visit, as it is very well designed and organised, and even includes a café. Its staff will tell you anything you want to know about the history of Wrexham.

In 1854 the Lord Lieutenant of Denbighshire called on the Justices of the Peace to build a home for the militia. This was the local army division, here to preserve public order and to

Wrexham Museum.

march to battle if a war ensued. This building was the result. It was home to the families of the sergeant-major and the quartermaster.

In 1877 the government reorganised the army and barracks were built around the country. The Royal Welch Fusiliers gained new barracks at High Town, so the militia moved location. The Chief Constable of Denbighshire took over the building so it became a police headquarters. In the 1970s the police and magistrates moved out. It became the Art College, then was remodelled and became the local museum.

63. The Westminster Buildings Gateway, Hope Street

DID YOU KNOW ?

A major exhibition was held in Wrexham in 1876.

Hope Street was given its name because it was the main road to Hope, the village on the border to the north-east. This entrance and gateway is all that remains of the agricultural and scientific exhibition held here in 1876. A temporary exhibition hall was built covering

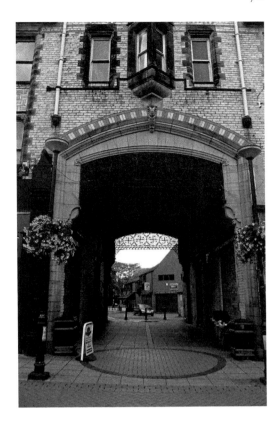

Gateway in Hope Street.

the land between Egerton Street, Rhosddu Road, Argyle Street and Hope Street. When it was built, there was much public protest at its cost. It contained displays of fine art, industrial design and local products – tiles, brick, terracotta, mineral water, brewing, engineering and much more. The exhibition represented industrial progress, but has since been demolished.

64. The Wynnstay Arms Hotel

DID YOU KNOW ?

The Football Association of Wales was founded in Wrexham.

Formerly known as the Eagles Inn (from which Eagles Meadow is derived), the hotel was surrounded by 8 acres of land in 1892. Its main entrance was decorated with stuffed birds and stags' heads and behind was stabling for around 200 horses.

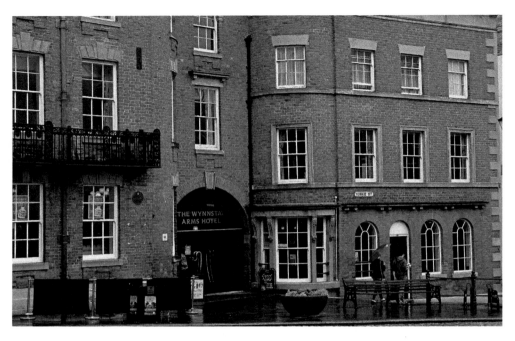

Wynnstay Arms Hotel.

This fine building sits at the end of High Street. It was a social centre and home to many meetings. In February 1876 local enthusiasts founded the Football Association of Wales here and created the first national football team to represent Wales. Another meeting, a century before, saw the Jacobite Cycle of the White Rose Society in creation and action.

In the 1960s a demolition was called for but this was resisted, so the building remains intact. It features in dozens of drawings and prints of the High Street.

65. Town Hill

DID YOU KNOW ?

Johnny Basham was a champion boxer – he bashed 'em.

Town Hill is the medieval heart of Wrexham. The oldest parts are adjacent to the churchyard. Nos 5–10 Town Hill still show very old characteristics, especially inside and around the rear. No. 9 (from the sixteenth century) was for many years Dodman's shoe shop, which stocked handmade shoes for men and women. It was founded by William

Old part of Wrexham, next to Town Hill.

Dodman in 1898, who was a trained cobbler; he made boots for miners and workmen's clogs. When the US Army was camped in Wrexham Dodman repaired their footwear. He was a boxing and pantomime manager, and was the manager of champion boxer Johnny Basham, who won the Lonsdale Belt in 1914. Johnny, a welterweight, had ninety-one fights with sixty-eight wins.

Next door was 'The Bon', a men's clothing retailer, which had impressive multiple windows and its fittings and counters were of wood with brass.

The original town hall (another victim of the demolishers) stood here at the junction of High Street, Church Street and Hope Street. Charles I is said to have made a speech to the public here. In 1583 the Catholic martyr Richard Gwynn was held in the Black Chamber before being taken to the Beast Market to be hanged, drawn and quartered. This is where Tesco now stands.

66. The Parish Church of St Giles

DID YOU KNOW ?

Wrexham's church steeple is a 'Wonder of Wales'.

St Giles' steeple is one of the Seven Wonders of Wales and is a central landmark. Wrexham's original church dates from the thirteenth century. In 1330 its tower collapsed and local people thought this was a punishment for having a market on a Sunday, so it was changed to Thursdays.

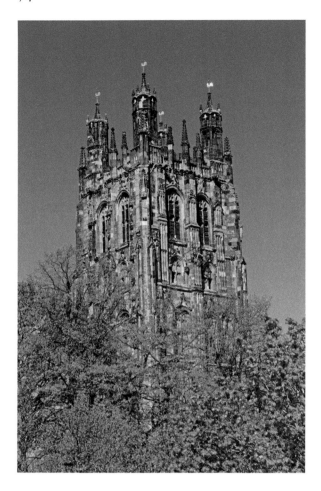

St Giles' Church tower.

In 1463 a fire destroyed this original church. Between 1463 and 1520 the new church was built with the help of patron Lady Margaret Beaufort. The design is medieval and Catholic, representing pre-Reformation design.

The churchyard gates are the documented work of Robert Davies in 1720. They are described by Hubbard as 'a beautifully frothy *clair-voie* with much scroll-work. Central pair of gates, side wickets and short screen lengths, all separated by two-dimensional piers. Each portion has its own overthrow. Pair of rusticated stone piers with urns.'

Oliver Cromwell used the church as stabling for his army's horses. In the nineteenth century both the famous William Morris and Sir Giles Gilbert Scott came to rescue the original design from plans to alter the church.

The tower can be ascended. At the west end is the grave of Elihu Yale. Temple Row and Church Street are adjacent to the church. College Street has a distinctive Welsh name – Camfa'r Cwn, meaning the dogs' stile. This indicates a desire to keep dogs out of the church and its environs.

It is a Grade I-listed building, described by Simon Jenkins as 'the glory of the Marches'. At 180 feet in length, it is the largest parish church in Wales.

67. Thomas Pennant (1726–98)

Wrexham can be proud that it educated one of the most distinguished men in the history of British science and letters. Thomas Pennant was a north-east Welshman, a son of Thomas Pennant and Arabella (née Mytton). The Pennant family came into possession of the house and land of Downing Hall, Whitford, Flintshire, in the early seventeenth century. Pennant received his early education at Wrexham Grammar School before moving to Thomas Croft's School in Fulham in 1740. His book *Literary Life*, published in 1793, tells of his first interest in ornithology when at the age of twelve he was given a book by Frances Willoughby on birds. This was given to him by his relative John Salusbury of Bachygraig, Tremeirchion, father of the writer and diarist Mrs Thrale. His book *Tours in Wales* (1379) describes his time in Wrexham. He entered Queen's College, Oxford, at the age of eighteen.

His first publications were on geology, featuring earthquakes, and on palaeontology. These impressed Carl Linnaeus so much that in 1757 he was elected to the Royal Swedish Society of Sciences. His *British Zoology*, published in four volumes in the 1760s, had 132 folio plates in colour; later, further appendix volumes were added. It was translated into Latin and German.

His scientific interests were wide and he travelled extensively, including to Scotland, Ireland and the Continent as well as England and Wales. The first volume of his *Tours in Wales* was published in 1778. Sir John Rhys edited his three-volume edition in 1883. He wrote *British Zoology* in the 1760s and '70s in four volumes, and he also wrote on the zoology of India and the Arctic regions. He wrote *Outlines of the Globe* in twenty-two

Thomas Pennant.

volumes, only a part of which was published. The manuscript is in the possession of the National Maritime Museum, Greenwich.

He was awarded honours from many European institutions including receiving an LLD from the University of Oxford in 1771, and the Freedom of Edinburgh.

On his travels he was accompanied by Moses Griffiths, self-taught draughtsman whose paintings of Welsh scenes and country houses are now sold at high values. Dr Samuel Johnson commented that Pennant was 'the best traveller I ever read'. Twenty-three species were named after him, with the epithets 'pennant', 'pennantii' and 'pennantiana'.

68. Coedpoeth

Coedpoeth is an interesting name for a community located to the west of Wrexham, on the Ruthin road. It has a superb view of Wrexham, the Dee and the Mersey. It has a population of 4,702 according to the 2011 census. '*Coed*' in Welsh means 'trees or wood'; '*poeth*' means 'hot'. Jocularly, it is called 'hot sticks'. This name may be derived from the practice of burning wood to make charcoal in the local woods.

It has an industrial heritage. There have been coal mines, lime and iron ore deposits and lead smelting at the adjoining Minera. The majority of the buildings in the village are made from local sandstone quarried at Penygelli quarries, with later buildings from Ruabon red brick.

Coedpoeth from Brymbo hill.

69. David Powel

Clergyman and historian David Powel was born around 1549 in Denbighshire. He went to Oxford at the age of sixteen. In 1571 he was a student of the newly founded Jesus College, and is thought to be the college's first graduate. He took his MA from All Souls in 1576 and became vicar of Ruabon. He was known as a student of Welsh history and was requested by Sir Henry Sidney to prepare a translation of a work in a manuscript of Humphrey Llwyd of Denbigh. He did so, adding new details of his own. So appeared *The Historie of Cambria, Now Called Wales* in 1574, which popularised the story that Prince Madog discovered America in around 1170.

In 1585 Powel published two works in Latin by Giraldus Cambrensis, omitting negative comments about the Welsh. They were *Descriptio* and *Itinerarium*. In the latter was an account of a visit to an underground fairy land by Elidorus. The details

Ruabon Church.

of this are so similar to Shakespeare's *A Midsummer Night's Dream* that it is possible that the dramatist, who could read Latin, borrowed them from this volume. Dr William Morgan's translation of the Bible in 1588 refers to Powel as one who assisted him.

Powel died in 1598. He had six sons and six daughters.

70. Wrexham Garden Village

The Garden Village movement started in 1901. Wrexham Tenants Ltd was founded in 1913 by Wrexham Co-Partnership Tenants Ltd. The Garden Village in Wrexham has an axial layout. Early buildings have gables and casements. Nos 157–167 Chester Road and others in Cunliffe Walk are early, as are dwellings looking across Wats Dyke Way. Originally, churches, institutes and shops were planned, but these were not built. Nos 63–69 Acton Gate were early larger houses.

Hubbard writes, 'The earliest buildings, some of them brick, some roughcast, are in the simple and informal vernacular style which characterizes so much of the best housing in the first half of the C20.'

Garden Village, Wrexham.

71. Holt and Its Castle

DID YOU KNOW ?

English monarchs once stored their treasure in a Welsh castle.

Holt Castle is one of the most historical places in Wrexham County Borough, and well worth a visit. It has not survived as a complete building, but remains still exist. It is on the Wales–England border, a few miles north-east of Wrexham town.

It was originally a huge building, pentagonal in plan with five massive round towers surrounding a central courtyard. It was hugely fortified, with inner and outer wards. It was built in 1283–1311 by John de Warenne and his grandson, earls of Surrey, after the defeat of Llywelyn ap Gruffudd, Prince of Wales.

Its design owes much to the famous James of St George, who designed Edward I's castles. It became a royal treasure house in 1397, and was attacked by the forces of Owain Glyndwr in his fight against Henry IV. In 1484 it became the home of Sir William Stanley, of the

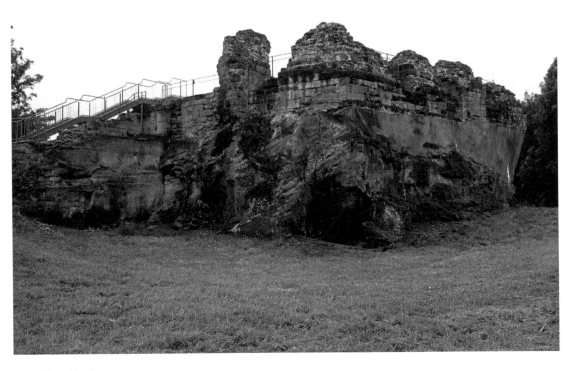

Holt Castle.

earls of Derby, after supporting Richard as king. After the defeat of Richard III at the Battle of Bosworth in 1485, it came under the ownership of Henry Tudor (Henry VII). In 1495 Henry visited the castle following the arrest of Stanley for treason.

In 1489, when his son Arthur was only three years old, Henry VII made him Prince of Wales. The king marked the occasion by robing his nobles with scarlet robes trimmed with miniver fur. Sir William's robe was in the castle at Holt, in the Great Wardrobe in January 1495, when an inventory of the contents was made by the king's commissioners. Here, £9,000 in coins as well as plate and jewels were held.

A font in St Chad's Church, Holt, carries a carving of a wild boar, the emblem of Richard III. William Brereton was beheaded by Henry VIII for allegedly having an affair with Henry's wife, Ann Boleyn; he was residing at Holt Castle.

In 1646, the Royalist cause was supported from the castle with a long siege, but it gave up when Charles I was defeated. Thomas Grosvenor had many stones removed and used them to build the original Eaton Hall, Chester. A seventeenth-century stained-glass building in Farndon church shows Civil War soldiers' uniforms, weapons and equipment. Farndon is on the Cheshire side of the River Dee, facing Holt.

72. The Cefn Viaduct (The Robertson-Brassey Bridge)

Only half a mile downstream from the Pontcysyllte Aqueduct, this is another spectacular building from the canal/railway age. It carries the railway line across the eastern end of the Vale of Llangollen, through Cefn Mawr. The line from Wrexham to Shrewsbury runs over it daily, proving its stability. It spans the River Dee with its 1,508-foot length and stands 147 feet above the river. It has nineteen arches with 60-foot spans.

On a memorable visit to the Cefn Country Park, I met a man sitting on a bench who said he came here often. 'I love that bridge,' he said. Indeed, it is one of the most beautiful multiple-arch bridges in the UK – an exercise in symmetry and texture. It has the power of beauty.

Henry Robertson was the instigator here. He proposed that a new railway bridge would open up markets for Ruabon and Wrexham coal to those at Chester, Birkenhead and Liverpool on one side, and Shrewsbury and other points on the other. Because of hostility from local landowners, he had to survey the site at night. One squire wished that someone would 'throw Robertson and his theodolite into the canal'. However, permission to build the bridge was granted and the railway contractor Thomas Brassey was given the task, which, after two years, was completed in 1848.

It was Henry Robertson, a Scot from Banff, who revived the Brymbo Iron Works, founding the steelworks in 1884, with another Scotsman, Robert Rowe. He also worked on the local John Wilkinson mines. He realised that if the potential of local mineral deposits

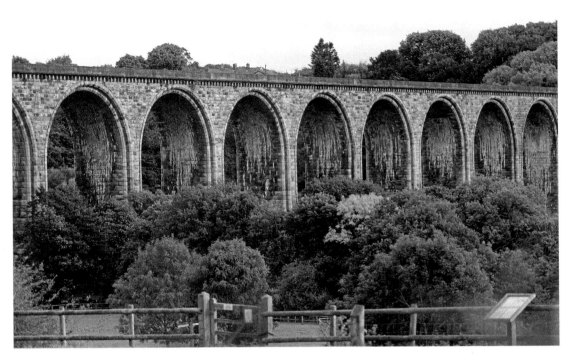

Cefn Viaduct.

was to be fulfilled, there had to be transport by railway, so the North Wales Mineral Railway was created. Robertson was the engineer and designer of the railways radiating from Shrewsbury, including the line from Ruabon to Llangollen, Corwen and Bala. Perhaps if it were given a new name, such as 'The Robertson-Brassey Bridge', the Cefn Viaduct would attract more attention.

Ty Mawr Country Park is situated close to the viaduct and is well worth a visit. It has an open aspect, on the shoulder of the Dee Valley, with excellent facilities for families and children, and has small animals and two llamas.

73. Thomas Brassey

Thomas Brassey was a remarkable man, a civil engineer and another leader from the canal/railways age. He had a hand in designing and building most of the railways of the world in the nineteenth century. By 1847 he had built around a third of the new railways in Britain. He died in 1870, by which time he had created one in every twenty of the world's railways. This included three-quarters of France's railways and major lines in India, Canada, Australia and South America. He also built structures associated with railways: bridges, stations, tunnels, docks etc. He built part of the London sewage system, which still

Thomas Brassey.

exists today. He was a major shareholder in Brunel's *The Great Eastern*, the only ship large enough to lay the first transatlantic telegraph, in 1864. (With thanks to the Plas Kynaston Canal Group, sponsored by Baynon Property Services)

74. Gwersyllt

The original village grew rapidly as a result of the coal trade and several collieries flourished. In 1896 the coal mine owned by Edward Griffiths had 185 employees, with 167 below ground. It was in operation until 1881. The area was situated between the collieries of the Moss Valley and Bradley and benefitted from good rail links on the Connah's Quay Railway to Wrexham. A canal was planned, evidence of which can be seen on the A541 close to Summerhill, but was not completed. A local street is called Heol-y-Gamlas, meaning Canal Road. The area had a population of 10,677 in 2011. The church is from plans by Thomas Penson. The Studio is the headquarters of the former Marcher Radio Group.

Gwersyllt Church.

75. Rugby in Wrexham

The North Wales Crusaders is a professional rugby club based in Wrexham. They compete in the Kingston Press League 1, the third tier of European Rugby League. They have played at the Racecourse Ground, but from 2017 they played on the Queensway Stadium, Wrexham. Some games are to be played at Hare Lane, Chester.

In 2009 the club moved from South Wales to Wrexham. In 2011 they became North Wales Crusaders. Their badge is in the gold and black of the emblem of St David, and shows the three-feather emblem of the badge of the Prince of Wales.

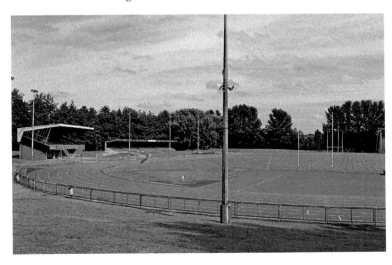

Queensway Stadium, Wrexham.

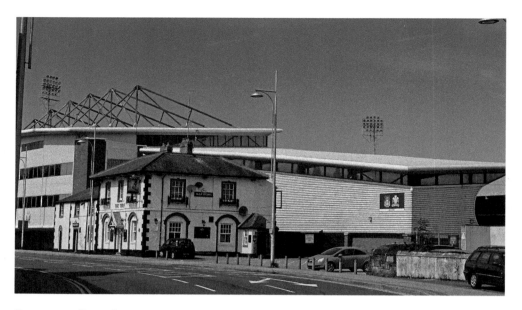

Racecourse Ground.

76. The Racecourse Ground

The name derives from horse racing. Built in 1807, it was host to the 'Town Purse' horse race. However, it developed a poor reputation for behaviour and horse racing ceased in 1864 when it became the home of Wrexham Football Club. It has a capacity of 15,500 and is the largest ground in North Wales, the fifth largest in Wales. The Wales National Rugby Team have played there.

77. Overton's Grand National Winner

The 1919 Grand National (at Aintree, Liverpool) was won by a horse named Poethlyn, ridden by Ernest Piggott. He was in the colours of Mrs Hugh Peel of Bryn-y-Pys of Overton. He was carrying the very heavy weight of 12 stone, 7 pounds; no horse since has had a victory carrying such a weight.

Poethlyn was bred by Major Hugh Peel in 1910. He was sold for £5 to Mrs Parry of the Black Lion Hotel, Ellesmere. Then he was sold for £7 to Mr Davenport of Whitchurch

Grave of Poethlyn, in a wood on the Bryn-y-Pys estate, Overton.

Farm, Alkington, where he pulled a milk cart. He was then sold to Mrs Peel for £50 plus a fresh salmon. He was trained by Harry Escott for the Grand National, where he was ridden by Lester Piggott's grandfather. Poethlyn died at the age of twenty-five and is buried in Bryn-y-Pys, Overton-on-Dee. (Thanks to Wrexham History)

78. William Low of Wrexham and the Channel Tunnel

The present tunnel was finished in 1994, and is actually three tunnels with a length of 31.5 miles. This project owes much to a Wrexham man, William Low, who lived on a site next to Crispin Lane. He was a Scotsman from Argyllshire who had the position of senior engineer of the Chester & Holyhead Railway. He was also involved in coal mining, being part owner of the Vron Colliery, Wrexham. He was also a consultant engineer on the building of the two viaducts over the Dee and the Ceiriog.

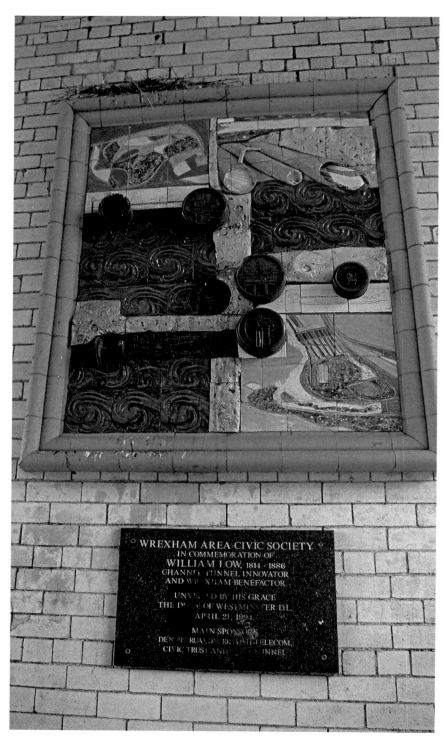

Plaque in memory of William Low, Argyle Street, Wrexham.

Lowe formed the Channel Tunnel Co. in the 1860s and was praised by Queen Victoria. He bought land in Dover and Calais and invested his own work in channel construction, on a route that followed grey chalk from the English to the French coast. In 1880 a new tunnel was commenced, based on Low's plans. Here Welsh miners drove through 1,000 yards. Low retired to London, where he died in 1886.

In Argule Street, Wrexham, under the arch, is a ceramic plaque marking his work.

79. The Rossett Gibbet

A gibbet is a pole with a crosspiece from which criminals were hanged. This happened as late as the end of the eighteenth century on Rosset Green, opposite The Golden Lion inn.

It was December 1776 and Charles Ellis and John Thomas had been drinking. On their way home Thomas attacked Ellis, stealing a pocket watch and a sum of money – he and tried to cut his throat. A Wrexham doctor ('surgeon') attended to Ellis the following day

The Golden Lion, Rossett.

and described serious injuries. On 5 December, Thomas was in Ruthin Goal, in custody for attempted murder.

In May 1777 a Great Sessions Court held in Wrexham tried Thomas and a jury found him guilty and pronounced the death penalty by hanging. This was done at Galltegfa, near Ruthin. Afterwards, Thomas's body was suspended by chains on a specially erected gibbet on Rossett Green. The body remained in a rotting state until John Thomas's widow protested. Then at the end of July and with Ann Jarvis she managed to cut down the remains of John Thomas. Thus John Thomas's body ceased to be a terrible example to others.

The Court of Great Sessions accused the women: 'the said gibbet on which the body of the said John Thomas otherwise known as John Jeffrey was then and there hanging in chains did unlawfully and wilfully cut down and destroy in manifest contempt and defiance of the Laws of this Kingdom and the order of the said Court to the evil example of all others in this case offending and against the peace of the said Lord the King his Crown and Dignity.' However, a trial found the two women not guilty. John Thomas's remains were probably buried at Rossett Green.

The spirit of John Thomas is said to haunt the Golden Lion. (Thanks to Wrexham History; research by Wayne Cronin-Wojat)

80. Wrexham Man Becomes Registrar of Oxford University

High Street, Wrexham.

Henry Fisher was a bookbinder at High Street, Wrexham. His son – another Henry – went to Oxford and matriculated at Jesus College in 1709, aged eighteen. He took his BA in 1714 and MA in 1717. He was made registrar of the university in 1737 and remained in this position until his death in 1761.

81. The Battle of Crogen

DID YOU KNOW ?

The Ceiriog Valley was the scene of one of the bloodiest battles in Welsh history.

This confrontation was one of the largest and bloodiest of the Welsh border battles in the medieval period. It took place in the summer of 1165 at Castle Mill, within sight of Chirk Castle, at the entrance to the Ceiriog Valley. A field at this point, adjacent to the River Ceiriog, is under edict not to be ploughed, which may indicate that human remains and

Site of the Battle of Crogen, Ceiriog Valley.

relics lie in the earth here. The present owner of the nearby Mill Cottage tells of how his father found a lead coffin in nearby woods, which he reburied.

On the one side were the forces of Henry II of England, who had raised an army at Oswestry with the intention of piercing Wales with a drive through the Berwyn Mountains. He intended to reach the defended castle of Rhuddlan and Basingwerk. Opposing him were the Celtic forces of Owain Gwynedd, the Welsh King of Gwynedd, and his brother Cadwaladr, who gathered at Corwen forces from all over Wales, including from the south-west Deheubarth, under Rhys ap Gruffudd, and forces from Powys, the tribal territory down the eastern side of Wales. Numbers of troops are not known, but they were substantial. The weather was very bad, and it is said that the Welsh were used to this, but the English forces were not.

Henry had the advantage of numbers, but the Welsh had the advantage of agility and experience in fighting in smaller groups. They used ambush tactics. The Ceiriog Valley is still heavily wooded and this gave the home side an advantage in cover and surprise.

Henry ordered around 2,000 men to clear the way through the woods, with pikemen to the fore. At the point where Offa's Dyke crossed the valley, there was a major confrontation at the place called 'The Gate of the Dead' – in Welsh Adwy'r Beddau, (The Pass off the Graves). This, with Owain's forces attacking the vanguard of Henry's army, was later called the Battle of Crogen. The King of England's life was saved by an intervention by Huge de Clare, constable of Oakwood Castle. The English forces were overcome, although some reached the Berwyn Mountains. Their supplies were cut off and they retreated to Chester.

Henry ordered that hostages be brought to him at Shrewsbury, where they were murdered, including the son of Owain Gwynedd. Henry was forced to abandon his attempt to suppress the Welsh and returned to his court at Anjou. Retaliation for the twenty-two murdered Welsh was carried out against Normans on the Welsh lands.

82. The Oak at the Gate of the Dead

This oak tree is said to be 1,000 years old. It is set in the Ceiriog Valley close to the place where the central battle of the opposing forces of Henry II and Owain Gwynedd took place in 1165. Many soldiers' remains exist in the ground. It may be that the 'Gate' in the term 'Gate of the Dead' refers to a gap in Offa's Dyke, which ran through here. This old oak, or what is left of it, sits just off the B500 some 2 miles from Chirk, running up the Ceiriog Valley. The old tree is badly split. Before this happened, it had a girth of 10 metres. When you look at it, you can imagine it in its youth as an observer of one of the most important battles in Welsh history.

This tree was nominated 'European Tree of the Year' in 2014 by the Woodland Trust (Coed Cadw). It said that it wanted a story 'that could bring the community together'. Trees

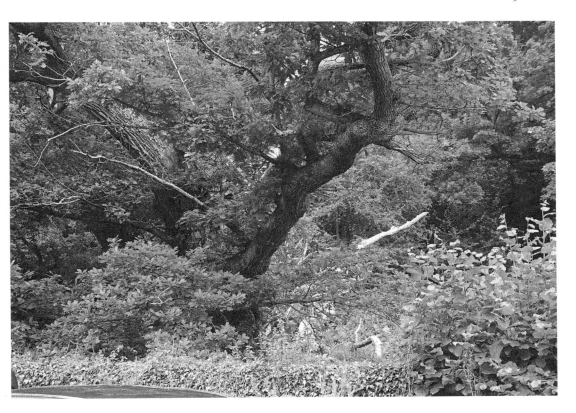

Oak tree, Ceiriog Valley.

from Bulgaria, Poland, etc. were entered. Some authorities place this tree back in the age of King Egbert in 802.

In 2010 a tree protection order (TPO) was placed on this oak by Wrexham County Borough Council.

83. The Simmons Family of Funfair Fame

Across North Wales, the coming of the funfair into your town was a time of anticipation and excitement. Local car parks were cleared and the dodgems, sliding rides and roll-a-penny booths took over. Men would leap from one swirling, swinging to another on a wavy wooden platform, and the sound of the generator dominated. Simmons coming into town was a great event.

The Simmons family had been doing this for over 130 years. The original man, John Litchfield Simmons, was a Wrexham man, running a menagerie and later a bioscope show. He died in his caravan on the Beast Market in 1903 and is buried locally.

Simmons Funfair.

In 1913 the business was expanded, with the help of chairplanes, gallopers and swingboats. In 1915 a girl of the family was born in the Foresters Arms, Rhos. She went on to own a Noah's Ark and a set of dodgems. Her children were born at Grosvenor Road Nursing Home, Wrexham, in the 1940s and '50s and they are still showmen. They are regarded as friends all across North Wales.

84. The Gates of Acton Hall

The gates are located on the Chester Road, Wrexham. They once guarded the entrance to Acton Hall, which was demolished in 1956. The entrance gates and lodge still remain. The hall, which dated from the mid-eighteenth century, was the home of the Cunliffe family

Acton Hall gateway, Wrexham.

and was also the home of the infamous Judge Jeffries. The lodge, which dates from 1887, was one of four that served the Acton Hall estate.

85. The War Memorial Hospital

This building, created in 1930, originally housed the main hospital of Wrexham before the large Maelor Hospital was built. It is, of course, called 'War Memorial' in memory of the fallen of the First World War.

Its open balconies show the devastation caused by TB, when patients were put out in the open air to try to clear the infection in their lungs. This was finally cured by the discovery of penicillin (an antibiotic) in the late 1930s by the famous chemist Alexander Fleming.

The building is currently in educational use under College Cambria.

War Memorial Hospital.

86. St Deiniol's Church, Worthenbury

Edward Hubbard writes, 'Rebuilt 1736–9, and there is no better or more complete Georgian church anywhere in Wales.' It is Grade I listed and was designed by Richard Trubshaw, who also had a hand in remodelling nearby Emral Hall, which was demolished in 1936. It was one of many beautiful country houses demolished in this area. However, this church survived, and stands as a testament to his exceptional design talent.

It is built of peach-coloured brick and stone. Its tower has three storeys, and balustraded parapets and urn finials. The clock is by Joyce of Whitchurch. The main windows are round headed and its north and south doorways have stone surrounds.

Inside, there are Ionic and Corinthian pilasters and a decorated ceiling. There is a rare group of box pews, some with fireplaces to allow servants to set a coal fire to keep their

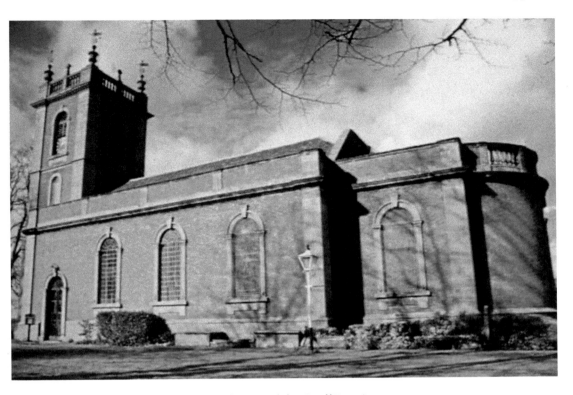

St Deiniol's Church, Worthenbury. (Photograph by Geoff Jones)

squire and his family warm during the service. Some carry the Puleston family crest, with pews arranged in order of social standing. The east window is made up of medieval fragments, mostly having come from the Jesse window of 1393 at Winchester College. A window here was recovered from the private chapel of Emral Hall.

87. Althrey Hall, Bangor-on-Dee

This building is a rare survivor. It is a Grade II-listed Tudor manor house and is believed to date back to 1499. It is one of the last surviving Aisle Trust Halls of Wales. Set over three floors, it includes a trusses Great Hall, private chapel, Minstrel's Gallery and significantly old decorative wall paintings. It stands on an elevated site with gardens overlooking the racecourse.

This is a timber-framed mansion, altered in the seventeenth century and remodelled in the nineteenth century. The house has been altered again more recently, in keeping with its original character. In the early fifteenth century, the house had an open hearth at its centre.

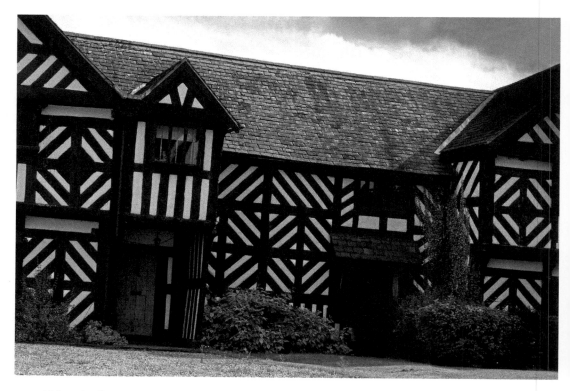

Althrey Hall, Bangor-on-Dee.

Old wall paintings seem to show the original builder, Ellis ap Richard, who died in 1558, both in court dress. Two of the walls in a guest bedroom show christening clothes from the Elizabethan period. The chapel on the upper floor has wall paintings and a hidden priest hole above the entrance. (The property is private and access is only possible with permission.)